Egyptian Sculpture

T.G.H. JAMES AND W.V. DAVIES

Published for
the Trustees of the British Museum by
BRITISH MUSEUM PRESS

Published by British Museum Press
A division of The British Museum Company Ltd
46 Bloomsbury Street, London WC1B 3QQ

Designed by Roger Davies
Printed in Hong Kong by Imago

THE TRUSTEES OF THE BRITISH MUSEUM
acknowledge with gratitude the generosity of
THE HENRY MOORE FOUNDATION
for the grant which made possible the publication of this book

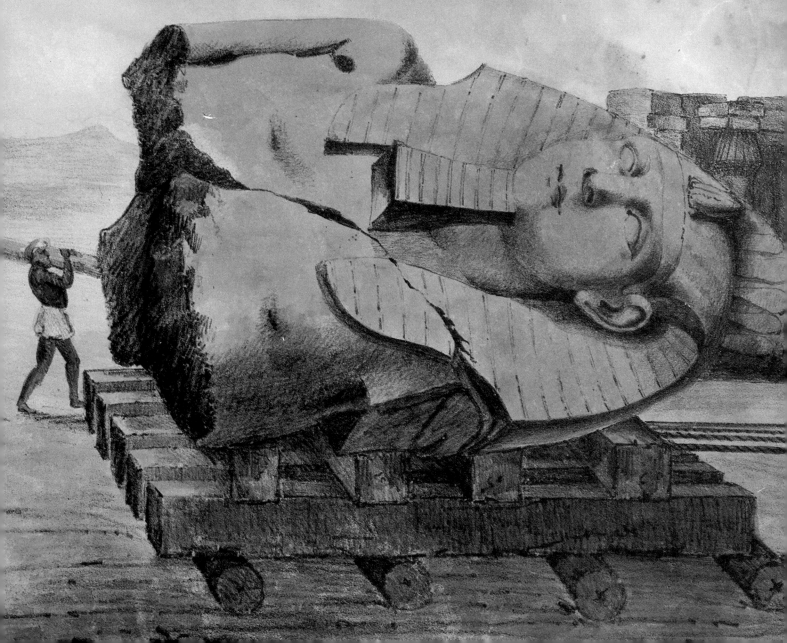

Contents

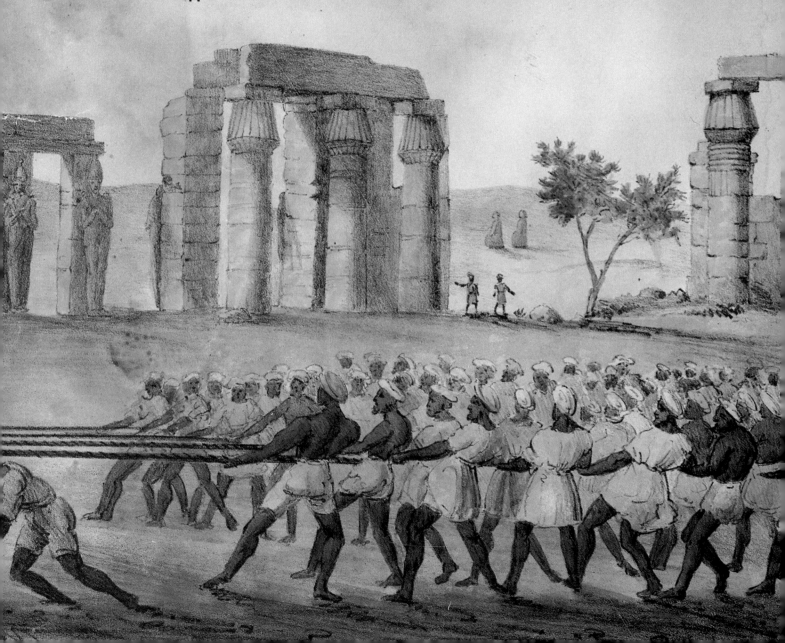

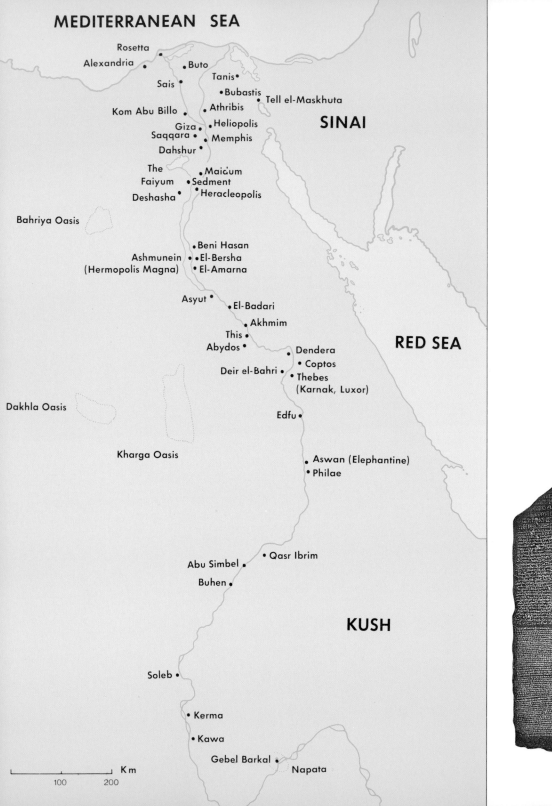

MEDITERRANEAN SEA

Rosetta
Alexandria
• Buto
Sais
Tanis •
• Bubastis
Kom Abu Billo •
• Athribis
• Tell el-Maskhuta
SINAI
Giza •
• Heliopolis
Saqqara •
• Memphis
Dahshur •
The
Faiyum
• Maidum
• Sedment
Deshasha •
• Heracleopolis

Bahriya Oasis

Beni Hasan
Ashmunein •
• El-Bersha
(Hermopolis Magna)
• El-Amarna

Asyut •
• El-Badari
• Akhmim
This •
Abydos •
• Dendera
Deir el-Bahri •
• Coptos
• Thebes
(Karnak, Luxor)

RED SEA

Dakhla Oasis
Edfu •

Kharga Oasis
• Aswan (Elephantine)
• Philae

• Qasr Ibrim
Abu Simbel •
Buhen •

KUSH

Soleb •

• Kerma

• Kawa

Gebel Barkal •
Napata

Km
100 200

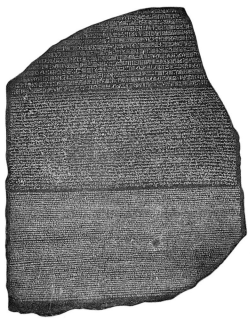

The Growth of the British Museum Collection

Sculpture in stone is the finest manifestation of Egyptian art. The artists of antiquity developed great skills in the working of the stones, both soft and hard, from limestone to basalt, with which the land of Egypt was very rich (*fig. 2*). In addition, however, they carved, modelled and cast in many other materials: wood, bronze, terracotta, ivory and also glazed quartz frit or glazed composition, erroneously, but inescapably, known as faience, in the use of which the Egyptians were masters. The collections of the British Museum's Egyptian Department offer a very representative survey of the whole field, from the small primitive figurines of predynastic times (before 3100 BC) to the veristic portrait heads of the Graeco-Roman Period (after 332 BC). Carving in relief was also practised with supreme competence in ancient Egypt, and many fine examples in low, high, and sunk relief are exhibited along with sculptures in the round in the great Egyptian Sculpture Gallery in the British Museum. A general survey of the achievement of the ancient culture of Egypt is presented in this gallery, and it will be mainly by a progression through this gallery that the Museum's collection will be examined. There are, however, many fine and interesting pieces in the upper galleries, dispersed among specialised exhibitions of aspects of Egyptian culture. A brief survey of these upper galleries from a sculptural point of view will complete the review.

The Egyptian collection of the British Museum is as old as the Museum itself. Within the vast stock of material of all kinds brought together by Sir Hans Sloane, which formed the foundation collection of the British Museum in 1753, was a small group of Egyptian antiquities, acquired apparently in quite a haphazard manner. There is no evidence that Sir Hans Sloane possessed any special interest in ancient Egypt; he was not, for example, a member of the Egyptian Society which flourished briefly in London between 1741 and 1743. The 150 objects of Egyptian origin which came to the British Museum after his death were, apart from one piece, of very ordinary kinds, objects which had come into Sloane's possession no doubt along with things of far greater interest. It was a very small beginning, and not very much was added to the Sloane nucleus during the remaining years of the eighteenth century.

These barren years, as far as the acquisition of Egyptian antiquities by the British Museum was concerned, reflected the difficulties faced by travellers in the Near East and Egypt at that time. The situation changed dramatically with the Napoleonic expedition to Egypt in 1798. Apart from its political goals, this enterprise aimed at finding out as much as possible about the land of Egypt, ancient and modern, in all aspects of its culture and physical character. Scholars and artists accompanied the French troops throughout the country, recording the standing monuments and collecting examples of ancient sculpture which were sent back to Cairo for study and, subsequently, onward transmission to France. After the defeat of the French in 1801, these sculptures were confiscated by the British. In due course they were presented to the British Museum by His Majesty King George III. This first great acquisition of sculpture was both a prize and an embarrassment to the Museum, the former because the group included the Rosetta Stone, the one piece which provided a real possibility for the decipherment of hieroglyphs (*fig. 1*) and the latter because there was no place in the existing building suitable for their exhibition.

Among the very heavy sculptures which came to the Museum along with the Rosetta Stone were the huge conglomerate sarcophagus of King Nectanebo II (no. 10), a group of lioness-headed granite statues of the goddess Sakhmet from Thebes (*fig. 39*) and a fine squatting statue of the high official Roy (*fig. 3*) also of granite and from Karnak. The inadequacies of Montague House, which had been the home of the Museum's collection from its foundation, were severely exposed by such acquisitions, and the position deteriorated rapidly in the early years of the nineteenth century with the arrival of the Townley Collection of classical sculpture in 1805. New galleries had to be constructed to accommodate the Egyptian and classical sculptures, and these were completed only just in

1 The Rosetta stone. The text, written in the Egyptian hieroglyphic and demotic scripts, and in Greek, contains a decree passed in honour of Ptolemy V Epiphanes in 196 BC. Height 1.14 m. (no. 24)

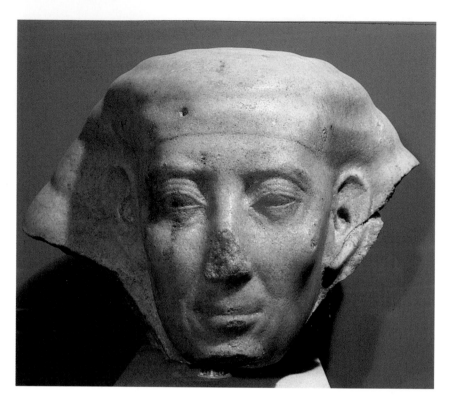

ecting with the British Museum distinctly in mind as the probable recipient. With the help of Giovanni-Battista Belzoni he acquired a large number of pieces, both great and small, which was sent back to London and purchased by the Trustees of the British Museum, greatly to Salt's disadvantage, in 1823. Many of the outstanding large sculptures which distinguish the Egyptian Sculpture Gallery came through the efforts of Salt and Belzoni: a further great head, probably of Amenophis III (fig. 36), a group of remarkable sculptures from the mortuary temple of the same king (*figs. 16, 42 and 45*) and other important royal monuments (*figs. 9, 37 and 50*).

Throughout the central decades of the nineteenth century the Museum's collection of Egyptian sculpture was substantially enriched by the acquisition of large groups of material from private individuals, or their heirs, who had visited Egypt in the early years of the century, at the time when Salt and Belzoni were at work. Most of these groups of antiquities contained large numbers of fine bronzes, terracottas, faience figures, and other small sculptures, which provided a counter to the great statues for a balanced estimation of the skills

2 Head of a man in crystalline limestone of Twenty-fifth-dynasty date, but showing archaising characteristics of Middle-Kingdom sculpture. A fine example of the Egyptians' skill in carving hard stones. Height 23.5 cm. (no. 37883)

3 *right.* Block statue of the high priest Roy. He holds the sistrum of the cult of the goddess Hathor before his legs; the lower part is made up. Height over all 1.13 m. (no. 81)

time to receive the most substantial series of Egyptian colossal and other sculptures ever to enter the Museum.

So far the Egyptian antiquities which were on display had done little to encourage the general public to find works of art among them. The statue of Roy was good; much better was a green schist royal head of the Late Period (*fig. 67*) (*c.* 600 - 250 BC), which came as part of the Townley Collection, but the piece which brought Egyptian art emphatically to the attention of connoisseurs, was the colossal bust of Ramesses II (front cover) which was presented to the British Museum by the Swiss traveller and explorer, Jean-Louis Burckhardt, and the British Consul-General in Egypt, Henry Salt.

As a result of the enthusiasm which greeted the arrival of this noble sculpture in the Museum in the spring of 1818, Henry Salt was encouraged to embark on a programme of antiquities coll-

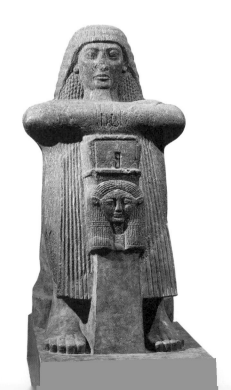

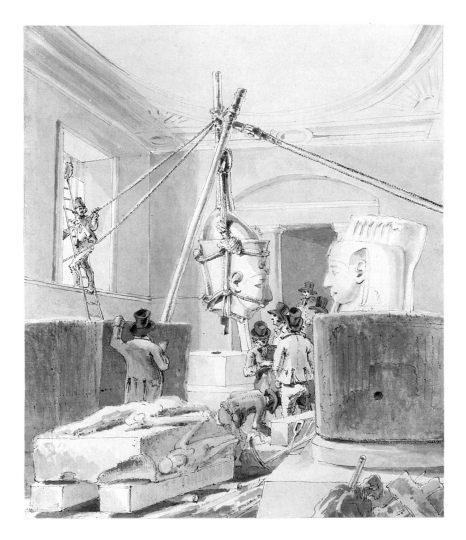

4 A detachment of Royal Artillerymen dismount Egyptian sculptures in the Townley Gallery in readiness for their move to the new Sculpture Gallery in 1834. The great head, probably of Amenophis III, from Karnak (no. 15) is removed from its mount.

Joseph Sams, a bookseller and antiquarian of great repute (1834), James Burton, one of the pioneer British Egyptologists (1836), Giovanni d'Athanasi, one-time agent of Henry Salt (1836 and 1837), Giovanni Anastasi, an Armenian merchant of Alexandria (1839), and Henry Salt himself, but posthumously (in a sale of his residual collection in 1835).

So, reinforced with many fine pieces, the collection of Egyptian sculpture once more outgrew its accomodation, and a fine new gallery was planned as part of the new building designed for the Trustees by Robert Smirke (*fig. 4*). The first stage of the new gallery was completed and occupied in 1834, and by the 1870s the whole of what is the present Egyptian Sculpture Gallery became devoted to the display of one of the finest collections of sculpture outside Egypt. Individual acquisitions had, in the meanwhile, filled many gaps and greatly strengthened the over-all representation of Egyptian statuary.

Up until the last quarter of the nineteenth century additions to the collection had come principally by gift, or by purchase in the sale-rooms of London. A more active policy of acquisition was pursued by E.A.W. Budge, who entered the Museum as an Assistant in 1883 and became Keeper of Egyptian and Assyrian Antiquities in 1894. He made many visits to Egypt purchasing large quantities of antiquities, including a number of outstanding pieces of sculpture. In the early years of the present century he organised the purchase from a Luxor dealer of a very important group of medium-sized sculptures of influential personages of the Eighteenth Dynasty and later: two very different statues of Senenmut (*figs. 7, 34*) and the quartzite statues of Tetity (no. 888), Amenwahsu (*fig. 44*) and Pes-shu-per (*fig.11*), were the particular prizes among them.

For the collection in its scholarly function, the most important development, the beginning of which coincided approximately with the start of Budge's active policy of purchase, was the presentation to the Museum of objects acquired through excavation. The Egypt Exploration Society was founded in 1882 (as the

and achievement of the ancient artists. In particular these acquisitions brought into the Museum hundreds of funerary inscriptions, many of which were carved with splendid scenes in low relief. The cemetery areas of Giza, Saqqara, Abydos and Thebes provided the bulk of these reliefs, and with them also came important inscriptions, like the Abydos King List (*fig. 5*), and the stela of Hor and Suty (*fig. 56*). The most important sources of all this rich material were John Barker, who had been Salt's successor as Consul-General in Egypt (1833),

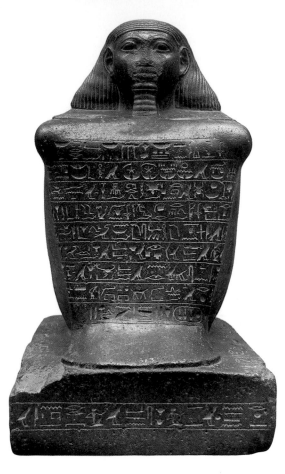

6 *below*. The excavation of the head of a colossal statue of King Amenophis III at Thebes in 1818 (no. 6). The colossi of Memnon, which marked the entrance to the mortuary temple of Amenophis III, can be seen in the background.

7 *left*. Quartzite block statue of Senenmut, the most influential state official during the reign of Hatshepsut. The face was deliberately mutilated, probably after Senenmut fell into disgrace towards the end of his career. Height 53.5 cm. (no. 1513)

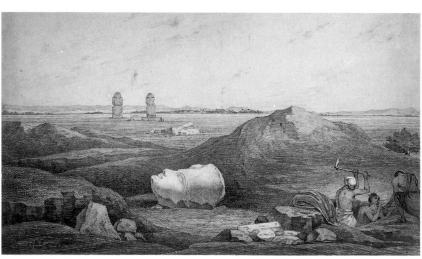

Egypt Exploration Fund), and from that time many of the finest antiquities, including sculptures, received by the Society in divisions of finds with the Egyptian Antiquities Service, have been presented to the British Museum. From Bubastis in 1889 came the wonderful colossal head of Ammenemes III (*fig. 31*) and the bust of Ramesses II (no. 1066); from Deshasha in 1897, the standing figures of Nenkheftka (*fig. 20*), the finest Old-Kingdom sculpture in the collection; three statues of Sesostris III from Deir el-Bahri came in 1905 (*fig. 29*). Similar gifts have continued to enter the Museum through the generosity of the Egypt Exploration Society up to the present; some of the finest bronzes exhibited in the Central Saloon of the Egyptian Sculpture Gallery came from excavations at Saqqara in recent years. The excavations of other organisations have also contributed important sculptures to the Museum, one of the most important of which is the wooden statuette of Meryrehashtef (*fig. 22*), which was found by Sir Flinders Petrie at Sedment.

The acquisition of Egyptian antiquities has slowed down considerably since the Second World War, but from time to time interesting and important pieces are still received through excavation, purchase and gift. A group of splendid bronzes was bequeathed from the Acworth Collection in 1946; a rare schist statuette of King Ramesses IV was purchased in 1958 (*fig. 57*); two pieces from the Temple of Mut at Thebes, excavated in 1896, were acquired in 1973 and 1982, one of which is a particularly sensitive head of a man (*fig. 72*); the bust of a crown-prince, possibly the later King Merneptah, was purchased in 1976. The additions will continue, but not as plentifully as in earlier times. Not only are the sources of new acquisitions from which antiquities may be properly obtained greatly restricted, but collecting is now conducted more selectively than formerly. Pieces to fill gaps in the collections are eagerly sought, but rarely found. Yet the gaps do not seriously diminish the excellent overall conspectus of Egyptian sculpture to be found in what is already exhibited in the British Museum.

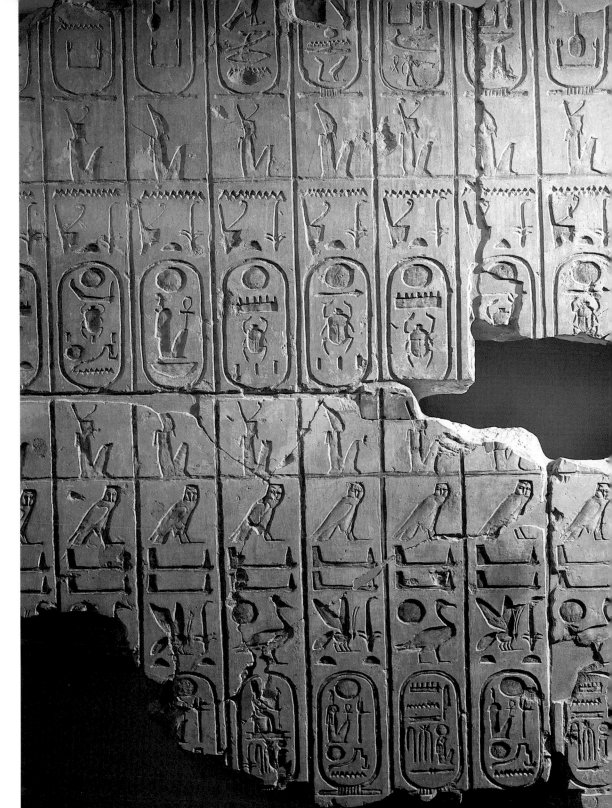

5 Part of the list of the kings of Egypt from the temple of Ramesses II at Abydos. Kings of the Eighteenth Dynasty are named in the upper row; the names of Ramesses II are repeated in the lower row. Height of surviving list 1.38 m. (no. 117)

The purposes, techniques and conventions of Egyptian sculpture

Very little of what may be classified as Egyptian art was made for simply artistic purposes. This limitation is distinctly true of Egyptian sculpture which was almost invariably produced for purposes other than art. What we might distinguish in an ancient sculpture as being artistic, or beautiful, would not perhaps have been comprehended as such by the ancient craftsman who made the sculpture, or by his contemporaries. It might have been admired for the excellence of the workmanship, for its rich embellishment, or for its suitability for its particular purpose. Ancient sculptors were, like other ancient Egyptian artists, mostly anonymous; their sculptures were the products of the exercise of their craftsmanship, made for practical purposes, and not, as far as we can tell, as expressions of their artistic impulses. Very little of what they carved was intended to be seen, whether three-dimensional sculpture or fine low relief; it was for the tomb, for the 'house of eternity'. The remarkable fact is that so many of these sculptures and reliefs, produced for the infinite gloom of the tomb, should possess qualities of artistic excellence which allow them to be compared without disadvantage with the finest products of other ancient cultures.

The Egyptian sculpture made for the tomb is called 'funerary' or 'mortuary'. The Egyptians believed that survival in the after-life depended in the first instance on the preservation of the body, in which dwelt the spirit or 'ka'. The daily funerary offerings in tombs were designed to nourish the dead person through his 'ka'. But if the body were destroyed, the 'ka' could still operate through the statues placed in the tomb, and even through the paintings and reliefs of the tomb-owner on the walls of the tomb.

Not all Egyptian sculptures were destined for the tomb. Very many were made for deposit in shrines and temples, and were dedicated to the particular deities worshipped there. These 'votive' statues represented their owners in life and death, in the expectation that they might participate in any benefits proceeding from the gods, either directly by divine intervention, or indirectly from the offerings presented daily to the gods. The intentions of those commissioning these sculptures were entirely practical, not artistic. They did not expect them to be examined as works of art by those people who were allowed access to the temple courts where votive pieces were placed. The only sculptures designed for inspection were the colossal statues set up in temples (*fig. 8*). These indeed were intended to impress, to enhance the appearance of the temple buildings, and to glorify the kings and deities so represented.

For whatever purpose a sculpture was made, its inscription was of vital importance, not only for the prayers contained in its invocation, but also in establishing the identity of the owner. An unidentified statue was incomplete, unless it was placed in close association with an inscription on a stela or on a neighbouring wall. No Egyptian would have relied on the ability of the sculptor to carve a true portrait for the perpetuation of his personality far into the indefinite future. The name was the thing, and by changing the name on a statue the identity of the person represented was also changed (e.g. *fig. 9*).

This reliance on the written name was largely due to the power with which the Egyptians invested the hieroglyphic script (called by them 'the god's words'); but a significant additional reason was the conventionality of the bulk of Egyptian sculptures. It is common for inexperienced people to say that all Egyptian sculptures look alike. This impression can quickly be shown to be too simple a reaction to a statuary of great variety produced within a tradition which lasted for three thousand years. The conventions of this tradition, which will be considered later a little more fully, provided a framework within which craftsmen could work with confidence, allowing them to produce sculptures of a generally very high order, and occasionally works of outstanding quality. Strict conventions of form, of bodily proportions, and even of style, helped craftsmen to follow and emulate the work produced by the master sculptors of the great metropolitan centres, Memphis and Thebes. During those periods when the whole land of Egypt was stabilised by

8 *right*. Façade of the Temple of Luxor. Much of the colossal sculpture which embellished the great gateway still remains, although heavily damaged. One of the original pair of obelisks is now in Paris.

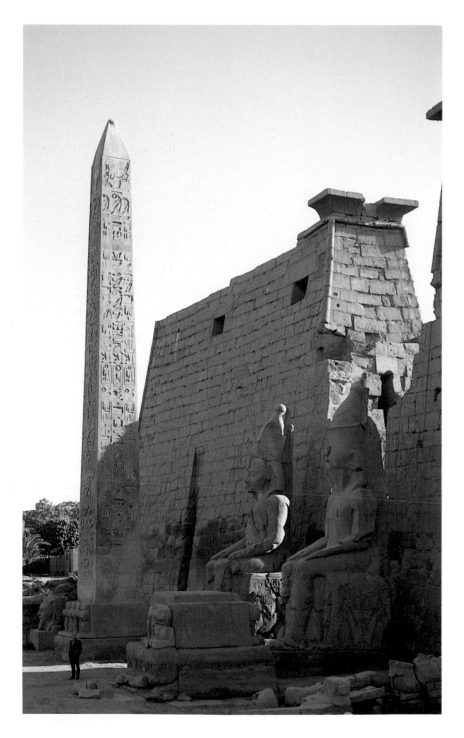

strong central authority the influence of these centres was strongly felt throughout the land, and artistic standards and trends were clearly transmitted to the provinces. In periods when central authority was relaxed or destroyed, the opposite happened. While some continuity of the tradition might be retained at the centres, the lack of contacts with the rest of the country resulted in remarkable divergences from the conventional norms in the provinces. When efficient central government was re-established after such periods of disunity as at the beginnings of the Middle and New Kingdoms (c. 2050 BC and c. 1567 BC), the artistic tradition quickly was revived both centrally and in the provinces. For this revival, the long-established conventions, properly observed in a tradition of skilled craftsmanship, were chiefly responsible.

Royal sculpture comes principally from the great temples of the land, most of which were cult temples where the king, as high-priest of the deity concerned, performed, in person theoretically, the daily rituals of service for the deity. Statues of the king found in such temples were magical substitutes for the king himself, which could participate in the personal relationship between god and king. Statues of the god in such temples, set up to honour him, for his and the king's advantage, were commonly portrayed in the contemporary style; the divine features were regularly modelled after the standard portraits of the king.

Apart from cult-temples, there were also mortuary temples devoted to the funerary cults of individual kings. From these temples come statues of the king principally set up to participate magically in the regular mortuary services established after the king's death, and in the offerings prepared for his posthumous existence. Both cult and mortuary temples were provided with further royal sculptures which fulfilled primarily architectural roles. Colossal standing and seated statues were placed before the pylons (monumental gateways) of temples, and further huge statues might be found in the courtyards of the temples. This practice was distinctly self-glorificatory, and was especially exercised by the great kings of the New Kingdom.

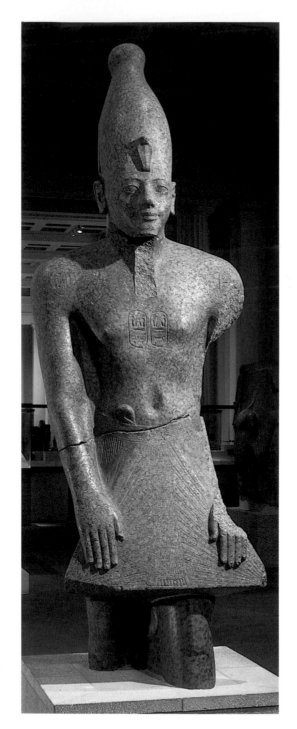

9 Granite figure of a king. Carved in the style of Eighteenth-dynasty royal sculpture, and possibly intended to represent Tuthmosis III or Amenophis II, it was later usurped by both Ramesses II and Merneptah of the Nineteenth Dynasty. The names of the latter pair of kings are carved on the torso. Height 2.63 m. (no. 61)

Notable examples from the mortuary temple of Amenophis III at Thebes are shown at the entrance to the Sculpture Gallery (*fig. 16*) and in the Central Saloon (*figs. 42, 45*); another great head, probably of the same king (*figs. 10, 36*) comes from the cult temple of the goddess Mut at Karnak. The colossal bust of Ramesses II, known as the Younger Memnon (*front cover*), comes from his mortuary temple, the Ramesseum, at Thebes, while a smaller colossal bust was brought from the cult temple of the goddess Bastet at Bubastis (no. 1066). The wonderful colossal head of Ammenemes III, which also comes from the Bastet temple at Bubastis (*fig. 31*) exemplifies the not-uncommon fate of usurpation suffered by royal statues. The lower part of the statue (which is not exhibited at present) is carved with a secondary inscription which names King Osorkon II of the Twenty-second Dynasty. To the modern student of Egyptian sculpture there can be little doubt that the head represents Ammenemes III; to the ancient Egyptian who could read hieroglyphs it would have been Osorkon II incontrovertibly once the new inscription had been cut.

The finest craftsmen in the land worked on royal sculptures, and the finest achievements of Egyptian sculpture are undoubtedly to be found in the field of royal statuary. But for variety and interest, and for the appeal of the simple and non-pompous, we should turn to private sculptures. The making of sculptures for private persons may always in theory have required royal permission, and the number and quality of a man's sculptures were clearly indicative of his standing with the king. The two votive sculptures (*figs. 7, 34*) of the steward Senenmut, the highly favoured official of Queen Hatshepsut, exhibited in the Southern Side Gallery of the main Sculpture Gallery are representatives of a known total which has reached at least twenty-three. In the Old Kingdom, burials frequently contained a multitude of sculptures, of which a fine representative is the statue of Nenkheftka (*fig. 20*). This piece presents its subject in one of the two principal poses used for mortuary sculpture during the Old Kingdom; he is shown standing, with his left

10 Royal torso lying in the Temple of Mut at Karnak—the body belonging to the great granite head (no. 15) shown in fig. 36.

leg advanced, and his arms close to his sides. The other common type shows the man seated on a simple block seat with his hands resting or clenched on his knees. A third type, developed at the same time, was the scribal statue in which the deceased person was depicted as a scribe, squatting on the ground and holding an open papyrus-roll on his lap. The profession of the scribe was always considered honourable, and even the greatest officials in the land were content to have themselves shown as scribes. The scribal statue of Pes-shu-per (*fig. 11*) is a very fine late example, dating from the Twenty-fifth Dynasty.

Funerary sculpture frequently placed emphasis on the family of the deceased, as well as on the individual himself. Group statues including man and wife, and sometimes children, were not uncommon during the Old Kingdom (*fig. 70*), and the pair statue of man and wife became one of the standard types of tomb-sculpture in later periods, an outstanding example (*fig. 43*) being exhibited in the Central Saloon. This attractive way of including the married couple, closely associated, in the tomb, formed a part of the general scheme by which the decoration of the tomb-chapel reproduced the environment in which the dead person hoped to pass his after-life. Fragments of reliefs from tombs, and especially the paintings from Theban tombs, shown in the Egyptian Sculpture Gallery and in the upper galleries, exemplify this purpose (*fig. 35*).

Sculptures deposited in temples for votive purposes were first made during the Middle Kingdom. They display a wide variety of types of which the most unusual and most characteristic is the block-statue. The subject is represented seated on the ground with his knees drawn up close to his chest, the whole body covered in a cloak which effectively conceals details of limbs. This neat and compact form offered good surfaces for the adding of inscriptions, and was, in consequence, very suitable

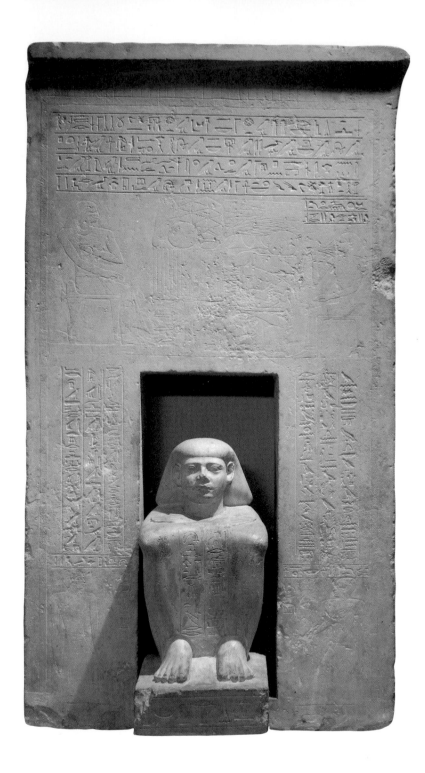

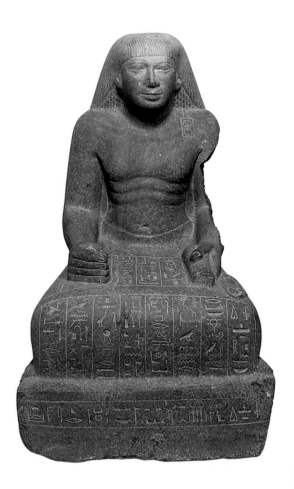

11 *below.* Quartzite statue of the chamberlain Pes-shu-per, represented in the attitude of a scribe. He is shown holding a papyrus roll in his left hand, with part of it open on his lap. Height 53 cm. (no. 1514)

12 *left.* Block statue in limestone of Sihathor, a treasurer of the king during the reign of Ammenemes II of the Twelfth Dynasty. It sits in its original niche in a funerary stela from Sihathor's cenotaph at Abydos. Height of stela 1.12 m. (nos. 569, 570)

13 *right.* Bronze cat, the living form of the goddess Bastet. The gold nose- and ear-rings are ancient, but may not have been made for this figure. A silvered pectoral bears the sacred eye of Horus. Height 38 cm. (no. 64391)

for votive purposes. The block-statue of Sihathor (*fig. 12*), one of the earliest dated examples, may have fulfilled votive and funerary purposes; others – a great many are on exhibition – are undoubtedly votive, and special mention may be made of those representing Senenmut (*fig. 7*), Sennefer (*fig. 40*) and Iti (*fig. 59*). Another type, originating as a funerary form in the Middle Kingdom, was the cloaked figure, shown either standing, seated or squatting. As with the block statue the sculptural effect was to simplify the form of the body, to eliminate the limbs, and to produce an impression of mysterious dignity. Yet, in the best examples, like the uninscribed granite standing figure exhibited in the South Side Gallery (no. 1237), the sculptor succeeds in suggesting bodily forms beneath the enveloping cloak in a most subtle and satisfactory manner. In the Twenty-Fifth Dynasty the cloaked type was revived for votive purposes.

While the votive statue in stone remained the privilege of the important person, others of less status were able to participate in what might be forthcoming from the beneficence of a particular god by depositing a bronze figure of the god in his sanctuary. This practice became very common from the seventh century BC, and remained so until the Roman conquest of Egypt. Most of the bronze figures on exhibition fall into this category, many of them bearing short inscriptions invoking a particular god on behalf of the person who made the deposit. Occasionally a bronze representing the person himself was deposited, after the manner of the stone votive figures, like that of Khonsirdais (no. 14466). Many of the large bronze animal figures, while still being votive in intent, were kinds of reliquary, holding mummified animals or parts of animals. The Gayer Anderson cat (*fig. 13*) is the outstanding representative of the most popular kind of animal bronze. Much remains to be learned, however, about the purposes for which many small sculptures in bronze, faience, glass, and other materials, were produced.

The conventions which formed the support-ive skeleton of Egyptian sculpture are not to be found in the types and forms of statues as such,

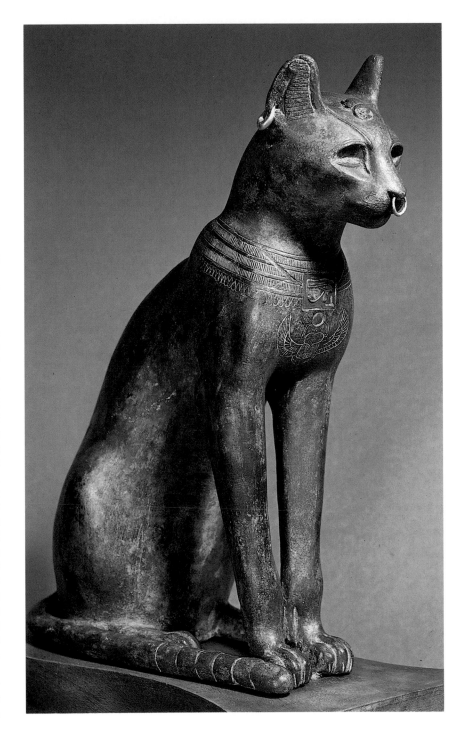

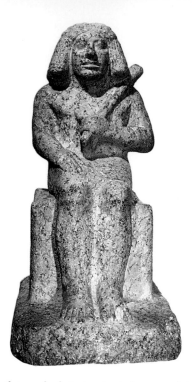

15 Seated statue in red granite of the ship-builder, Ankhwa, holding a carpenter's adze over his shoulder. The piece well exemplifies the Egyptian sculptor's early mastery of the working of hard stone. Height 64 cm. (no. 171)

but in the underlying principles on which the proportions of the human figure were based, and in the ways of representation, particularly again of the human figure, which were maintained throughout the Pharaonic Period. The canon of proportions, established at least by the early Old Kingdom, provided the Egyptian artist-craftsman with an analysis of the human body in terms of a unit based on the width of the fist. In well-preserved, unfinished, two-dimensional paintings and reliefs, it can be seen that the artist made use of a grid particularly for the correct placing in a scene of the most important figures, and very often less important figures (*fig. 14*). This grid, drawn in red paint, was used both as an aid to transfer a figure from small to large scale, and as a guide to help the artist establish the proper proportion of such a figure in his preliminary outline. In so doing, the grid unit represented the width of the fist of the figure to be drawn within it, while eighteen squares were allowed as the conventional distance between the ground-level on which the figure was placed, and the hair-line above the eyes on the face. Generally speaking, the

shape of the body and the positions of the various parts were similarly established in a conventional manner. There were, as should be expected, many variants within this general rule, and at different periods changes of significance were introduced. But overall the grid, embodying the underlying canon of proportions, remained a constant support and guide to the artist, imparting to his work the unmistakable flavour of Egyptian conventional art.

The exploitation of the grid can best be observed in unfinished paintings and reliefs, and it is in paintings and reliefs that the peculiarly Egyptian conventions of representing the human figure can be seen. Almost without exception figures are depicted with the head turned sideways, in profile, but with the eye shown as if from the front. Frontal representation is used for the shoulders, while the chest is given in a three-quarters view and the legs again in profile. A further peculiarity of the conventional representation is that hands and feet, both right and left, are shown commonly without distinction. These two-dimensional conventions, which greatly puzzle new-comers to Egyptian art, were not applied in the making of statuary in the round. But the conventions based on the canon of proportions were observed, and were certainly used in the preliminary stages of carving, in the form of the grid, and subsequently by the use of guidelines. A few final guidelines can be seen on the almost finished wooden statuette from the tomb of Meryrehashtef on view in the Fourth Egyptian Room (no. 55723).

In the carving of stone the ancient Egyptians achieved complete mastery. Their skills in working granite, quartzite, basalt, diorite, schist, and the many other hard stones found in the country, were developed during the late Predynastic Period in the manufacture of stone vessels. Consequently, when sculptures of some size began to be produced in the early dynasties, the skills were available to allow craftsmen to tackle hard stones as well as the relatively soft limestone which in fact became the most common material for statuary down to the end of the New Kingdom. A fine early example of

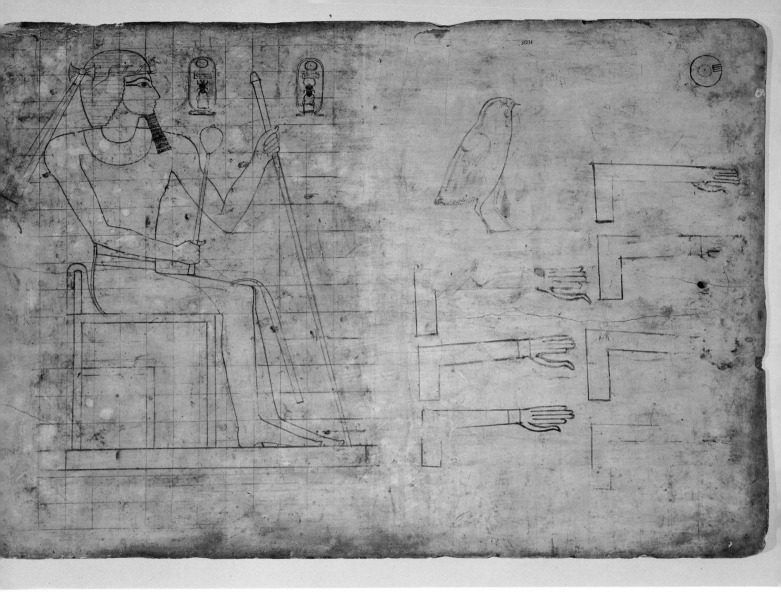

14 Drawing board, covered with a thin layer of fine plaster, marked out in red with a grid within which is drawn a seated figure of Tuthmosis III composed according to the system of bodily proportions which governed Egyptian art from the time of the Old Kingdom. Height 36.4 cm. (no. 5601)

hard stone sculpture in the British Museum is the granite statue of Ankhwa (*fig. 15*). Limestone was carved with copper, or in later times bronze, chisels and with flint tools. Hard stones were much more laboriously shaped with pounders and grinders of even harder stone, like dolerite. In griding, sand was used as the medium, and it was also used to produce the final polish with which hard stone sculptures were usually finished. Fine details and inscriptions were worked with drills, again with the

help of sand. Indeed, sand was an essential material for the working of hard stones, and happily it was readily available in large quantities throughout Egypt. Finished sculptures, particularly those made of limestone, were often painted in order to make them as lifelike as possible, and for the same purpose the eyes were sometimes inlaid. This last practice was most common during the Old Kingdom, but there are interesting examples from later periods (e.g. nos. 44, 1063).

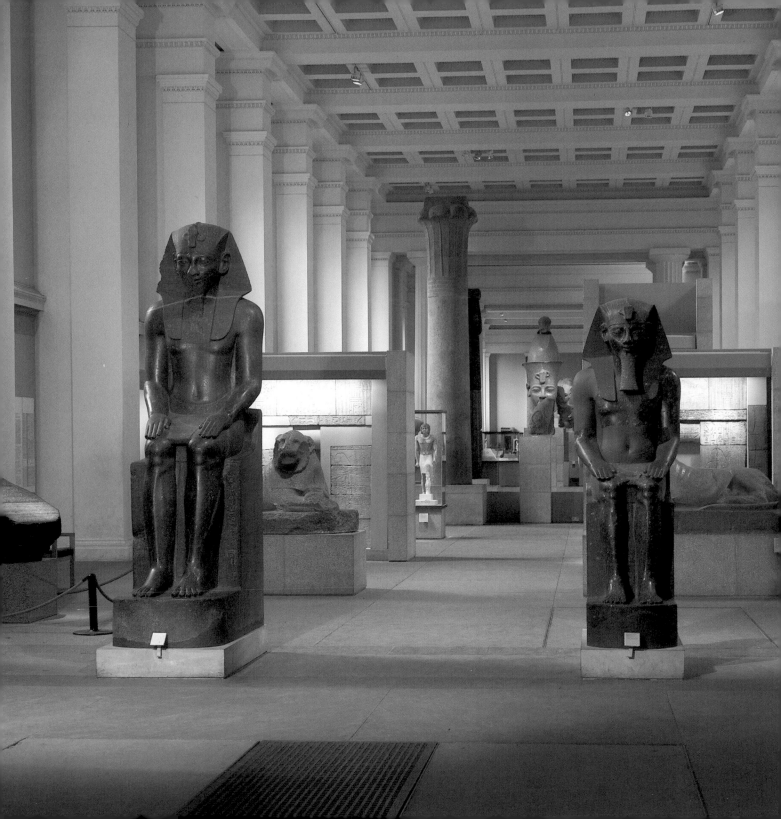

The Southern Sculpture Gallery

Ideally, the visitor should approach the Egyptian Sculpture Gallery from the direction of the Museum's main entrance and enter the exhibition at its southern end. Here there is a brief introductory area, the beginning of which is marked, much in the style of the entrance to an Egyptian temple, by two large royal statues (nos. 4 and 5). Made of black granite, they represent King Amenophis III of the Eighteenth Dynasty (1417 - 1379 BC, fig. 16) one of the great builders of ancient Egypt, shown in characteristic royal pose and dress. The king is seated on a throne with his hands placed flat on his thighs, wearing the short shendyt-kilt to which is attached a ceremonial bull's tail shown between the legs. On his head is the nemes-headcloth fitted with an uraeus at the front. He also wears a false beard and a large ornamental collar. On the larger statue hieroglyphic inscriptions are carved on the king's belt and on the front and rear of the throne, giving the king's names and titulary. The sides of the throne are decorated with a motif symbolizing the union of the two lands, Upper and Lower Egypt, which also occurs on the small statue. Both figures come from the site of the king's mortuary temple on the west bank of the Nile at Thebes. This temple, once one of the largest of its kind, has now all but disappeared, its sandstone blocks pillaged by later kings for their own constructions. All that substantially remains today are the famous huge seated quartzite statues known as the 'Colossi of Memnon', which flank what was once the temple's entrance, and at the rear end a large stela (inscribed stone). The broken sculptures which have littered the site since antiquity provided rich pickings for the early collectors, much to the subsequent benefit of the British Museum. In addition to the two black granite figures, a sizeable number of other important statues were removed by Belzoni and Salt. These are exhibited in the Central Saloon of the gallery.

The lions of red granite (nos. 1 and 2) which lie a little beyond the seated figures are also attributable to Amenophis III (fig. 17). The one on the left bears an original inscription naming the king. The one on the right appears to have been left unfinished to be later inscribed by Tutankhamun (1361 - 1352 BC). Both were originally set up as guardian figures before the temple of Amenophis III at Soleb in Nubia but were transported south from there to Gebel Barkal by the Meroitic ruler Amanislo in the third century BC, who had his names carved on the lions' breasts. These sculptures are often cited as excellent examples of the Egyptian artist's special ability to represent animals, even on a monumental scale, with skill and sympathy. Though recumbent, the lions are dignified and alert, their bodies imbued with a latent power and strength. Their eyes were once inlaid.

The four statues just described mark the limits of an introductory area, which is devoted to the Egyptian language and its scripts and to the history and chronology of ancient Egypt. The two main features here are the Rosetta Stone on the left (fig. 1, no. 24) and the Ramesside king list from Abydos on the right (fig. 5, no. 117).

The Rosetta Stone is probably the most celebrated of all Egyptian antiquities. Discovered by chance by French soldiers in 1799 at Rashid (Rosetta) in the west Delta, it was ceded to the British in 1801 under the terms of the Treaty of Alexandria and reached the British Museum in 1802. The stone is part of a black basalt stela originally about six feet high, which was set up in 196 BC to commemorate the honours bestowed upon Ptolemy V by the temples of Egypt. The text is rendered in three different scripts: hieroglyphic and demotic, which are both Egyptian (demotic being a highly cursive version of hieroglyphic script developed in the later stages of Egyptian history), and Greek. It was the presence of the Greek, which could, of course, be read, that provided the key to the decipherment of Egyptian, a crucial step in the process being the realization that the prominent oval rings (the so-called cartouches) in the hieroglyphic section contained the name of Ptolemy, thus enabling the phonetic value of a number of hieroglyphs in these rings to be established. Much valuable preliminary work was done on the texts in the years immediately following the stone's discovery, most notably

16 Entrance to the Egyptian Sculpture Gallery marked by two seated statues of Amenophis III, with the Rosetta stone on the left.

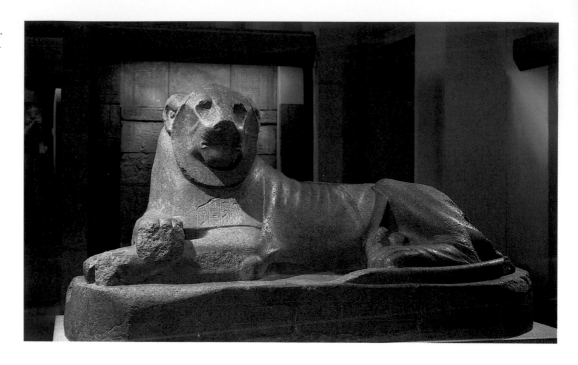

17 Statue in red granite of a recumbent lion, one of a pair originally set up as guardian-figures before the temple of Amenophis III at Soleb in Nubia. It bears a dedicatory-text of Tutankhamun on the pedestal and a much later inscription of the Meroitic ruler Amanislo on the chest. Height 1.17 m. (no. 2)

by the Englishman, Thomas Young (1773–1829), but the final decipherment was the achievement of the Frenchman, Jean François Champollion (1790–1832), who in a paper published in 1822, supplemented by another a year or so later, convincingly demonstrated the principles underlying the hieroglyphic script and its predominantly phonetic nature. These momentous papers of Champollion mark the beginning of modern Egyptology.

The painted wall relief on the opposite side of the gallery is a good example of the type of document which, once the hieroglyphs were understood, proved invaluable to Egyptologists in their attempt to build up a chronological framework for Egyptian history. It comes from the temple of Ramesses II (c. 1304–1237 BC) at Abydos and consists essentially of a list of the previous kings of Egypt (their names written in cartouches) thought worthy of commemoration by Ramesses. The list is damaged and the only dynasties substantially represented are the Twelfth and Eighteenth. As was the usual

practice in such cases, kings that were disapproved of, such as the Pharaohs associated with the Amarna heresy at the end of the Eighteenth Dynasty (c. 1379–1348 BC), are omitted. A better-preserved version of this list is to be found in the Abydos temple of Sethos I, the father of Ramesses II.

Beyond this introductory area, the gallery is arranged in chronological order, beginning with the monuments of the Old Kingdom (c. 2686–2181 BC) and ending, at the northern end, with those of the Graeco-Roman Period (330 BC–440 AD). Most of the Old Kingdom material on display consists of limestone wall-reliefs and false door stelae (so called because they are in the form of blind doors) from the tombs at Giza and Saqqara, the two great cemetery sites of the Old Kingdom capital Memphis. Tombs of this period comprise a substructure, wholly underground, in the form of a burial shaft and chamber which held the sarcophagus, and a superstructure in the form of a decorated chapel, often divided into several rooms, flat-

roofed and bench-shaped (called 'mastaba' from the Arabic word for 'bench'). The most important element in the chapel was the false-door stela, which was situated over the burial chamber. The Egyptians believed that the dead man's spirit or 'ka' ascended the burial shaft and gained access through the stela to the offerings placed before it by the funerary priests.

This belief is given concrete expression in the false door of Bateti (*c*. 2400 BC), where a figure of the deceased is carved half in the round as if emerging from the central niche of the stela (no. 1165). This figure replaces the more usual central panel of the typical false door, which invariably shows the deceased seated before a table of offerings. An early example of such a panel, the earliest in the collection, is exhibited next to Bateti. It comes from the false door of the prince Rahotpe from Maidum (*fig. 18*) and dates to the early Fourth Dynasty (*c*. 2550 BC). In keeping with the man's royal status, the workmanship is of the highest quality, with particularly fine detailing of the hieroglyphs. In other false doors on display the panel can be seen in its proper relation to the other elements

of the door: a horizontal lintel above, long vertical jambs on either side, and a cylindrical drum below, just above the central niche. All these features are decorated with hieroglyphic inscriptions which served to identify the deceased and his family and to invoke offerings on their behalf from the gods. While the function and content of these false doors were essentially the same, a considerable variation in the pattern of decoration is observable, even within the same dynasty. Thus in some of the doors of the Fifth Dynasty (*c*. 2494 – 2345 BC), for example on the double false-door of Tjetji and his wife Debet (nos. 157 A and B) and on that of Kainefer (no. 1324), the human figures are prominent, while on that of Ptahshepses (no. 682) the available space is almost wholly taken up by the texts, an arrangement which was to become standard in the later Old Kingdom. The false door of Ptahshepses (*fig. 19*) is worthy of attention for another reason. Most inscriptions on false doors are wholly religious in content but those of Ptahshepses contain a substantial biographical element of some historical interest. They record his birth in the time of King Mycerinus of the Fourth Dynasty, his marriage to a princess Khamaat, and his subsequent career under four more kings of the Fifth Dynasty.

Adjacent to the false door of Ptahshepses is a painted limestone figure (no. 1239) of the same dynasty, which is probably the finest Old Kingdom stone statue in the collection. It represents a nobleman named Nenkheftka (*fig. 20*) and is one of a large number of statues of varying type discovered in his tomb at Deshasha. In this statue he is shown in the classic pose for the Egyptian standing figure, the left foot forward, the arms held straight down by his sides, the hand clutching the traditional bolt of cloth believed to be a symbol of authority. The base is lost but would originally have borne his name and titles. The body is painted red, the conventional colour for the male figure, as opposed to yellow for the female. As often on the finest sculptures of this period, careful attention has been paid to the anatomical detail of the body in order to emphasize the muscularity and

18 Limestone stela of Rahotpe from his tomb at Maidum. As is customary on such stelae, the central figure is the owner, shown seated on a chair with his hand extended towards a table of offerings. The carving is done in shallow relief of the highest quality. It was originally finished in paint. Height 79 cm. (no. 1242)

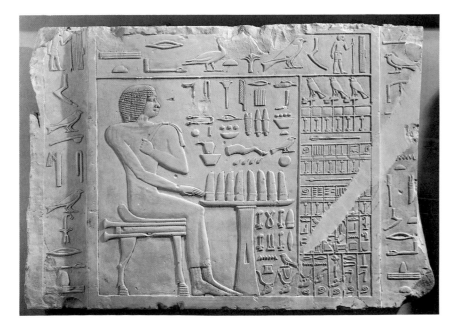

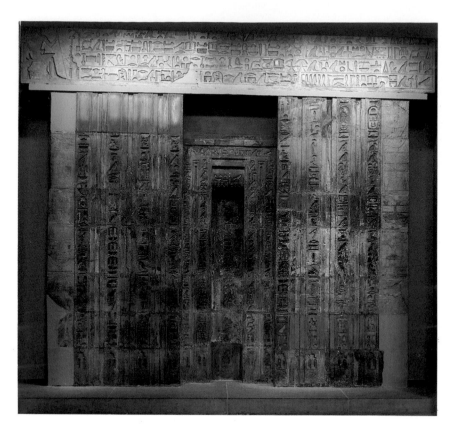

19 Limestone false-door of Ptahshepses from his tomb at Saqqara. In addition to the usual funerary formulae, this door bears an interesting biographical text recording the owner's birth in the Fourth Dynasty, his marriage to a princess, and his subsequent career under several kings of the Fifth Dynasty. Height 3.66 m. (no. 682)

strength of the owner. The face has also been crisply modelled, though the features lack perhaps the touches of individuality which would mark it out as a true portrait. Statues of this kind were placed in the tomb to partake magically, on behalf of the owner, in the food offerings and to act as a substitute in the case of the destruction of his body. They were generally located in sealed chambers in the chapels, referred to as *serdabs* (after the Arabic for 'cellar'), which had small slit windows through which the figure(s) could observe the rituals.

To the side and behind the false door of Ptahshepses are mounted the surviving parts of the mastaba of another Fifth-dynasty official, Urirenptah (no. 718). The decorated elements include not only a double false door, for the owner and his wife, but also a wall relief showing characteristic scenes taken from daily life. Among them may be recognized the rendering of accounts, bird-netting, various agricultural pursuits, and the preparation of the owner's bed, all stock topics in the repertoire of the tomb decoration of this period.

More Old Kingdom monuments are exhibited in the side gallery which is situated on the east of the main Sculpture Gallery, the southernmost area of which also contains material dating to the period immediately preceding the Old Kingdom, known as the Early Dynastic Period (c. 3100 – 2686 BC). Confronting the visitor at the first entrance to this smaller gallery is the false door of Kaihap from his tomb at Saqqara (no. 1848). It is constructed of two large pieces of limestone of equal size and of very good quality. In keeping with the material, the workmanship is of a high standard throughout, the carving of the heads of the owner and his wife on the inner jambs being particularly fine. The monument is notable for being a gift of the Egyptian Government to the British people in recognition of the financial support received from the British Government for the Nubian Rescue Campaign. At the southern end is the splendid red granite statue of the boat-builder Ankhwa (*fig. 15*). Solidly impressive, he sits on a stool holding an adze, the characteristic tool of his trade, over his shoulder. Dating to the Third Dynasty (c. 2686 – 2613 BC), it is the earliest intact private statue of stone in the collection. Although a little confined in overall conception, it is a highly accomplished piece of sculpture, the modelling of the details of the body and the face being every bit as careful and effective as that of the later soft-stone statue of Nenkheftka already mentioned. This statue shows clearly how already at this relatively early date the Egyptian craftsman had completely mastered the technique of working very hard stones, a skill revealed also in the splendid Early-Dynastic vessels of porphyritic diorite and red breccia (nos. 35698–9) displayed on either side.

Stone was not, of course, the only material in which the Egyptian artist excelled. The diminutive figure of a king (no. 37996) in the adjacent wall case is made of ivory (*fig. 21*). Though incomplete and fissured, enough of it remains

to show the great delicacy and minute attention to detail of the original carving, particularly of the king's long jubilee robe. Wooden sculpture is represented by a fine Old Kingdom bust once fitted with inlaid eyes (no. 47568) and by the standing figure of Meryrehashtef (*fig. 22*) from his Sixth-dynasty tomb at Sedment, one of a series showing him at different stages of his life. This figure depicts him as a young man and is much noted for its remarkable expression of tense physical energy (no. 55722).

By-passing the entrance to the side gallery the visitor enters an area devoted to the First Intermediate Period and early Middle Kingdom (*c.* 2160 – 2010 BC). Here are displayed several examples of the new small type of funerary stela which largely replaced the false-door type of the Old Kingdom. Most are rather gauche in execution and reveal a distinct decline in artistic quality, though some, such as the stela of Sebekaa from Thebes (no. 1372), compensate for this by the variety and liveliness of their vignettes. The stelae of this period tend to be highly localized in style and in the form of their hieroglyphs, reflecting the fragmented political situation of the period.

The resurgence in quality which begins to occur during the first half of the Eleventh Dynasty is illustrated by the large limestone stela of Tjetji from Thebes (*fig. 23*). This is a monument not only of high artistic merit but also of some historical significance, as it bears a long biographical inscription which sheds interesting light on the prevailing political situation. Egypt at this time was ruled by two rival families, one governing in the north, from Heracleopolis, and the other in the south, from Thebes. Tjetji served under the kings Inyotef I and II (*c.* 2125 – 2069 BC) and records that under the latter the limits of the Theban kingdom lay at Elephantine in the south and at This in the north. In the end Thebes prevailed and Egypt was reunited under one king, Nebhepetre Mentuhotpe (*c.* 2060 – 2010 BC), the founder of the Middle Kingdom. It is this king who is represented in the large sandstone head which stands on a plinth in the centre of this section (no. 720). The King wears the white crown with

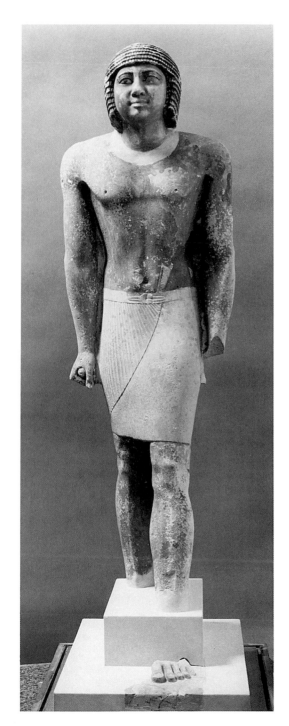

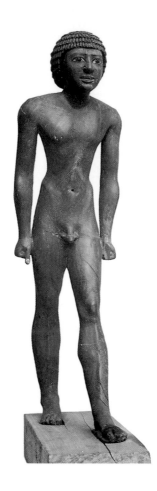

22 Wooden figure of Meryrehashtef from his tomb at Sedment. This is one of a number showing him at different stages of his life. In this case he is portrayed as a young man. Height 50.8 cm. (no. 55722)

an uraeus at the front which was originally painted yellow in imitation of gold (*fig. 24*). The face has a formal, primitive quality about it, an effect accentuated by the wide boldly-coloured eyes. It is impossible to say whether the statue from which the head comes was seated or standing but it is practically certain that it was of a type showing the king wearing the *heb-sed* or jubilee robe. It was excavated in the king's mortuary temple at Deir el-Bahri, which has yielded numerous other statues in similar style both seated and standing. This temple, now in great ruin, was a remarkable building constructed on two levels and embellished with colonnaded halls. It was decorated throughout with brilliantly coloured reliefs. Unfortunately, these were almost all smashed into pieces when the temple eventually fell into disuse. Some idea, however, of the richness and variety of the decoration can be gained from the fragments mounted on the wall to the left of the head. One shows the king himself in the embrace of two gods in the performance of a ritual (no. 1397); another is part of a battle-scene (no. 732) where the king's foreign enemies fall helplessly from the battlements of a fortress, their bodies pierced by arrows.

Stelae were not always strictly funerary in purpose. It was common practice during the Twelfth and Thirteenth Dynasties for private officials to set up offering chapels at the site of Abydos, though they were actually buried elsewhere. These chapels, which were constructed of mud brick, commonly contained several stelae as well as offering tables and statuary. These were designed for votive purposes to enable their owners to benefit from the mysteries of the Abydene deities and to share in the divine offerings. The group of the statue and three stelae of Inyotef come from a chapel of this kind (nos. 461, 562, 572, 581). The statue has an unusually high pedestal which suggests that it might originally have been placed in a separate plinth (*fig. 25*), possibly with an offering-table in front of it. The group is dated to the reign of Sesostris I (*c.* 1971 – 1928 BC), a black granite statue of whom is displayed at the top of the central ramp leading into the side gallery (no.

44). Another Abydene group, like Inyotef's but slightly later in date and of more unusual form, is the niche-stela and statue of Sihathor (nos. 569–70). In this case the statue is housed in a rectangular recess at the bottom of the stela (*fig. 12*). Particular interest attaches to the form of this statue. It is of a type known as a 'block-statue' showing the owner squatting on the ground his body enveloped by a cloak. Dated to the reign of Ammenemes II (*c.* 1929 – 1895 BC), it is one of the earliest known examples of this type.

In addition to the evolution of new types of statue, another significant development in private sculpture in the Middle Kingdom was the increasingly common use made of hard stones such as quartzite and black granite. In the main gallery the standing statuette of Senebtyfy, also named Ptahemsaf (*fig. 28*), and the seated figure of Ankhrekhu (nos. 24385 and 1785), are both quartzite sculptures of the highest accomplishment. Scarcely less impressive, within the side gallery, is the group of three black granite figures, squatting, standing, and seated (nos. 1842, 1237 and 462), which face the exit to the ramp. Also outstanding is the anonymous bust of a man (no. 98), of the same material, exhibited in the section beyond (*fig. 26*). This is exceptionally well modelled and the eyes are hollowed to receive inlay. Two holes from above the eyebrows, which descend right through to the sockets, show that the inlay was secured by means of dowels, a very rare fixing technique. The lack of an inscription leaves the man unidentified but it can be assumed that the owner of such a large and handsome statue was a personage of some considerable standing. In the case adjacent is another anonymous antiquity made for a person of high rank, in this instance possibly a princess. It is a mummy-mask (no. 29770), designed to cover the head of the dead owner, and is made of cartonnage, a material consisting of layers of linen and gesso-plaster, which is decorated with gold leaf (*fig. 27*). Such masks were influential in furthering the development of coffins, their increasing use leading gradually to a change in coffin shape from the traditional rectangular form, as ex-

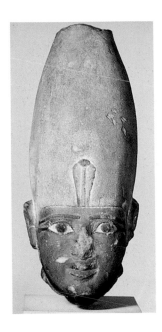

23 *right.* Limestone stela of Tjetji from Thebes. Tjetji is the larger of the figures represented at the bottom of the stela. Above him is a biographical text which sheds interesting light on the political situation in Egypt during the first half of the Eleventh Dynasty. Height 1.52 m. (no. 614)

24 *above.* Sandstone head of Mentuhotpe II from his temple at Deir el-Bahri, Thebes. This head once belonged to a statue showing the king dressed in the jubilee or *heb-sed* robe. The uraeus-cobra at the front of the white crown was originally painted yellow in imitation of gold. Height 38 cm. (no. 720)

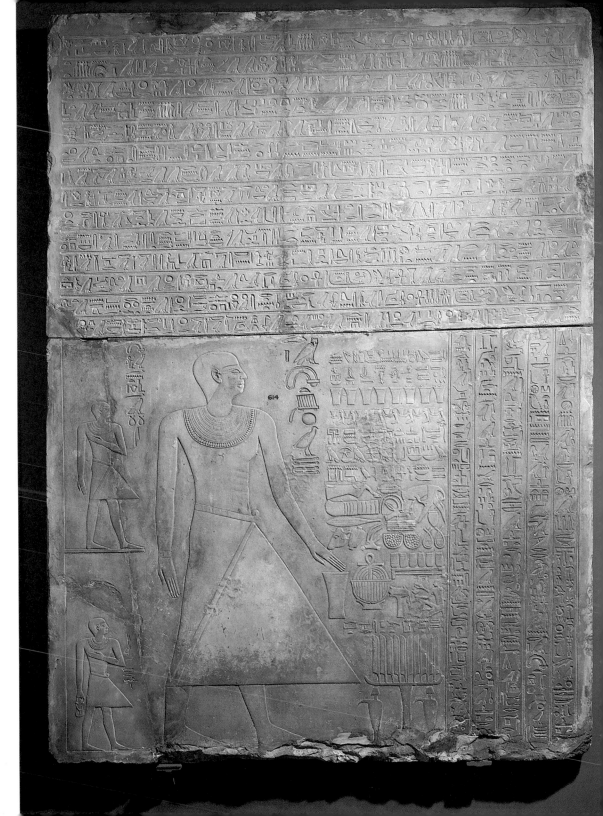

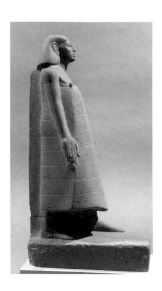

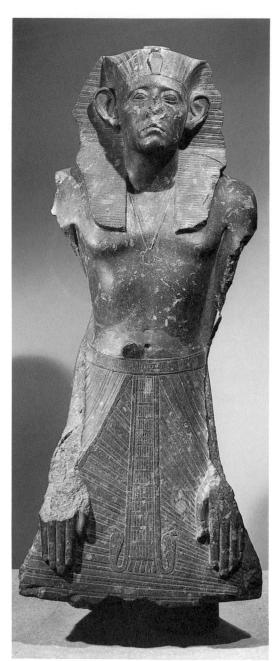

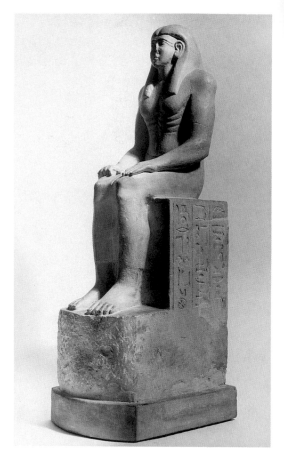

28 *above.* Quartzite statue of Senebtyfy, also named Ptahemsaf. Private statues made of quartzite, one of the hardest stones worked by the Egyptians, became increasingly common during the late Middle Kingdom and Thirteenth Dynasty. Senebtyfy's dress is highly characteristic of that worn by officials and dignitaries during these periods. Height 51.5 cm. (no. 24385)

29 *right.* Black-granite statue of Sesostris III from Deir el-Bahri, Thebes. This is the finest of three almost identical statues of this king in the collection. It well illustrates the new realistic style of royal portraiture introduced during his reign. Height 1.22 m. (no. 686)

emplified in the nearby coffin of Sen from El-Bersha (no. 30842), to an entirely mummiform variety.

Following the chronological arrangement of the material the visitor may now re-enter the main gallery down the central ramp, passing on the way the granite statue of Sesostris I and the quartzite statuette of Senebtyfy (*fig. 28*) already mentioned. Facing him as he descends is a group of three life-size black granite statues which are identical in stance and garb (nos. 684–6). They represent King Sesostris III of the late Twelfth Dynasty (*c.* 1878 – 1843 BC) and were excavated from the site of the temple of King Mentuhotpe at Deir el-Bahri. They are among the most important statues in the collection,

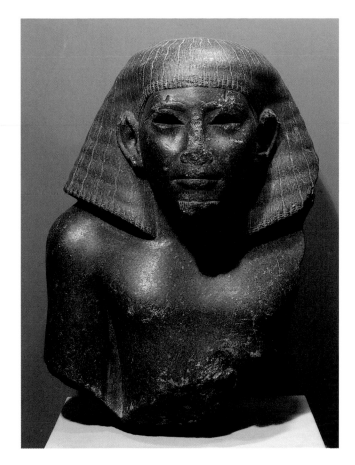

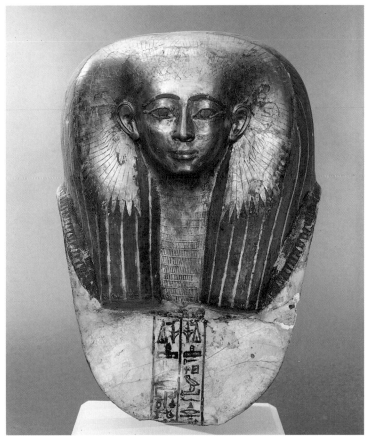

26 *above*. Upper part of a statue of a man in black granite. The eyes of this exceptionally well modelled figure were hollowed to receive inlays, which were secured by means of dowels. The holes, through which the dowels were inserted, are visible above the eyebrows. Height 48.5 cm. (no. 98)

27 *above right*. Mummy-mask of a lady made of gilded cartonnage. The owner is unidentified, the columns of inscription at the bottom containing only the beginnings of two funerary formulae, but the presence of the vulture headdress in addition to the wig indicates that she was royal. Height 61 cm. (no. 29770)

25 *left*. Limestone statue of Inyotef. This figure is one of a group of monuments set up in Inyotef's offering-chapel at Abydos. The pedestal is unusually high, suggesting that the statue might originally have been placed in a separate plinth. Height 64 cm. (no. 461)

the one on the left (*fig. 29*) being widely regarded as a masterpiece of Egyptian sculpture. Though all differ slightly in treatment, each exhibits the new realistic mode of delineating the facial features so characteristic of this king's portraiture, a style of representation which was to be followed by his successors in the dynasty and in the following Second Intermediate Period, as well as in the private sculpture of the same periods. The king's pose, with his hands placed flat on the front of his kilt, is also an innovation of this reign. The same king's features are clearly recognizable in the red granite head from Abydos (*fig. 30*, no. 608) at the bottom of the ramp, as are those of his successor, Am-menemes III (*c*. 1842 – 1797 BC), in the magnificent

black-granite head from Bubastis (no. 1063, *fig. 31*) on the opposite side. This head, which once had inlaid eyes, belongs to a seated statue (not exhibited) bearing an usurping inscription of King Osorkon II of the Twenty-second Dynasty (*c.* 874 – 850 BC). Fortunately, the iconography of Ammenemes III, like that of his predecessor, is sufficiently distinctive to leave little doubt that he is the king represented in this fine portrait.

Very few good-quality royal sculptures from the period immediately following the Twelfth Dynasty, known as the Second Intermediate Period (Thirteenth to Seventeenth Dynasties), exist outside Egypt. Prominent among this small number is the large seated figure of red granite (no. 871) which lies to the north of the ramp, across the gallery from the seated statuette of Ankhrekhu. The piece is inscribed for Sobkemsaf I (*fig. 32*), third king of the Seventeenth Dynasty (*c.* 1642 – 1628 AD). The exaggerated treatment of the body's anatomy and the incongruous porportions of the torso in relation to the legs and head make the statue an excellent, if extreme example of the highly mannered style of representation which is typical of the sculpture of this period. There are also other points of interest. The observant visitor will have noted the dowel-holes in the eyebrows above the hollowed sockets of the eyes and recalled the similar holes on the anonymous Middle Kingdom bust (no. 98) in the side gallery. In both cases the same means for securing the inlay in the eyes was employed, a technique otherwise unparalleled. In addition, on the royal statue, dowels were used to fix overlays on the eyebrows. Another unusual feature is the nature of the decoration on the statue's rear. It consists of a motif in the form of two figures of the hippopotamus goddess Ipi accompanied by an inscription which invokes protection for the king.

Leaving the statue of Sobkemsaf the visitor may conveniently enter a section of the side-gallery devoted to small sculptures and tomb-paintings of the Eighteenth Dynasty. The outstanding sculpture here is the royal head of green schist (no. 986), done in the typically suave idealizing style of the middle period of

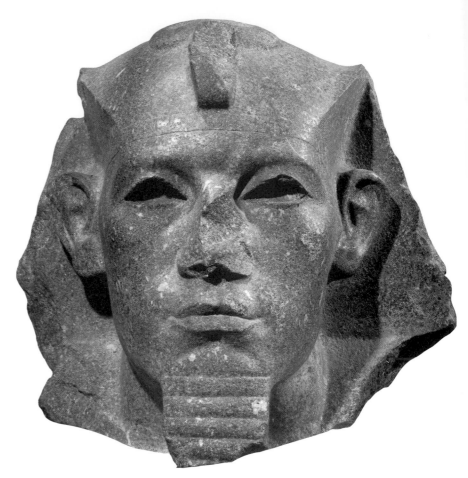

the dynasty, a far remove from the realism of Sesostris III. The head well illustrates the problems of attribution which often attend upon sculptures lacking an inscription (*fig. 33*). While there is no doubt that the head represents a Tuthmoside ruler, it is still a matter of scholarly debate whether this is Tuthmosis III (*c.* 1504 – 1450 BC) or his co-regent, Queen Hatshepsut (*c.* 1503 – 1482 BC). Most of the private statues shown here are of the same date. The quartzite squatting figure of Tetity (no. 888) bears the cartouche of Tuthmosis III on its right shoulder, while two of the others represent the famous Senenmut, the architect of Queen Hatshepsut's great temple at Deir el-Bahri. One (no. 1513) shows him, like Tetity, as a squatting figure of quartzite

31 Black-granite head of a king from Bubastis. This fine head, which once had inlaid eyes, belongs to a seated statue bearing an usurping inscription of Osorkon II of the Twenty-second Dynasty. The original owner is identifiable, on firm stylistic grounds, as a much earlier king, Ammenemes III of the late Twelfth Dynasty. Height 79 cm. (no. 1063)

33 *right.* Royal head in green schist. Definitely Tuthmoside in style, this finely finished head repreasents either Queen Hatshepsut or her co-regent and successor, Tuthmosis III. Height 45.7 cm. (no. 986)

32 *below.* Seated statue in red granite of Sobkemsaf I, one of a very small number of royal figures surviving from the Seventeenth Dynasty. The eyebrows were once decorated with overlays and the eyes with inlays, which were held in place by dowels. Height 1.64 m. (no. 871)

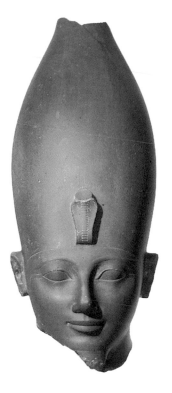

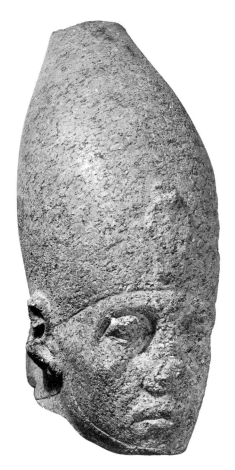

30 *left.* Red-granite head of Sesostris III from Abydos. Although separated from its body and lacking an inscription, the head is easily recognizable, through the style and detail of its portraiture, as a representation of Sesostris III. Height 86.4 cm. (no. 608)

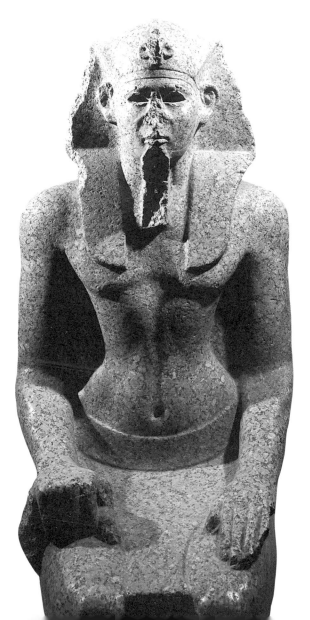

37 Four-sided monument in red granite from the temple of Karnak, Thebes. The sides of the monument are decorated with six figures carved in very high relief. Two represent Tuthmosis III, the others the deities Montu-Re and Hathor. The function of this monument, and of others like it, is unknown. Height 1.78 m. (no. 12)

(*fig. 7*). The second, made of black granite, is less conventional (no. 174). It represents him seated on a throne, holding on his lap his ward, Hatshepsut's daughter, the princess Neferure (*fig. 34*). There are at least twenty-three known statues of Senenmut, an enormous number for a private individual and ample testimony to his great status during Hatshepsut's reign. All the

private statues in this section, including those of Senenmut, continue and develop types – block-statues, seated and standing cloaked figures – already introduced in the Middle Kingdom. It is noticeable, however, that in these later examples fuller advantage is taken of the simplified planes offered by such figures to use them as vehicles for inscriptions.

The Eighteenth Dynasty was not only a great age for achievement in the plastic arts. Owing largely to the unsuitability of the rock at Thebes for relief carving, it also saw the emergence of painting as a fully independent medium of representation in its own right. Examples of Theban tomb-painting are mounted on the walls at the northernmost end of the side-gallery (nos. 37977, 37984 and 37991). Contemporary with the sculptures described above, their subjects – hunting, banqueting, and the reception of foreign tribute – are among the favourites of this period. The excerpts from the tomb of Nebamun (nos. 37977 and 37984), showing fowling in the marshes and the entertainment of guests at a banquet (*fig. 35*), are among the finest surviving specimens of their kind, celebrated for the artistry observable in their subtle use of texture and shade and for the extraordinary liveliness conveyed by the unusual views and poses of some of the minor figures.

Returning to the main gallery, the visitor confronts the colossal head of red granite (no. 15) and its attendant arm (no. 55) which dominate the area of New Kingdom sculpture in front of the Central Saloon (*fig. 36*). The head weighs four tonnes and is over two and a half metres high. It came originally from a standing statue, and were it complete with its body it would be far too tall to be accommodated within the gallery. Discovered by Belzoni in 1817 the piece was for many years attributed to Tuthmosis III, largely through misinterpretation of the circumstances of the find, and was thought to come from the temple of Amen-Re at Karnak. Fortunately, the problem of its exact provenance has recently been resolved by the discovery of what is evidently its torso lying still *in situ* in the precincts of the temple of Mut, where Belzoni must have found the separated head and arm.

34 *below.* Seated figure in black granite of Senenmut. An unusually large number of sculptures was made for this important official, who served Queen Hatshepsut. His close relationship with the royal family is emphasised by statues such as this showing him holding on his lap Hatshepsut's daughter, the princess Neferure. Height 76 cm. (no. 174)

35 *right.* Tomb-painting of a feast. Banqueting was a favourite subject of Theban tomb-decoration in the Eighteenth Dynasty. This fragment from the tomb of a scribe called Nebamun is much noted for the lively portrayal of the entertainers. Height 61 cm. (no 37984)

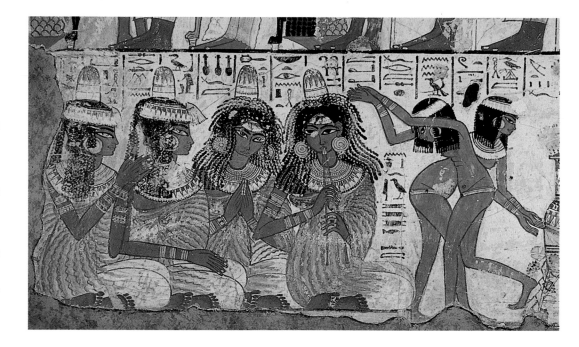

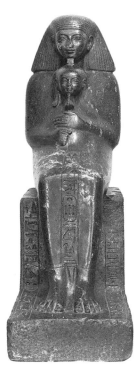

The torso once had an inscription on the rear but this was thoroughly destroyed at some time in antiquity, so the king represented remains unidentified. The statue is now, however, thought on good stylistic grounds to belong to Amenophis III, though it has been suggested that some modification may have been made to it in the Ramesside Period. The usurpation of the monuments of earlier rulers was a common practice of the Ramesside kings. The large standing figure of red granite (no. 61) to the left of the great head is a case in point (*fig. 9*). The style of the facial features, which may be compared with those of the green schist head (no. 986) in the side gallery, indicate that the statue was originally made for Tuthmosis III (*c*. 1504 – 1450 BC) or his successor, Amenophis II (*c*. 1450 – 1425 BC). The inscriptions on the body, however, name two Ramesside kings. On the belt and the shoulders are the names of Ramasses II (*c*. 1304 – 1237 BC), and on the chest those of his son and successor, Merneptah (*c*. 1236 1223 BC). The original Tuthmoside inscription was probably erased, though it is just possible

that the statue was never inscribed for its first owner.

More certainly attributable to Tuthmosis III is one of the most unusual monuments in the exhibition (*fig. 37*). It is the curious rectangular monolith of red granite (no. 12) from Karnak, which is situated behind the colossal head in the centre of the gallery. Its sides are decorated with six figures in very high relief, two of which, the most prominent, represent the king, the others depicting the falcon-headed god, Montu-Re, and the female deity Hathor. All the figures are identified by accompanying inscriptions. The king's head is missing from both his figures, the shape of the break in each case showing that he was wearing the white crown. The significance of this monument is obscure. Two other examples are known, both similarly unrevealing of their purpose. It has been suggested that such monuments served as pedestals for large ritual water basins, but this idea has yet to be confirmed.

To the right of the monolith is another royal sculpture, of earlier date. Unprepossessing at

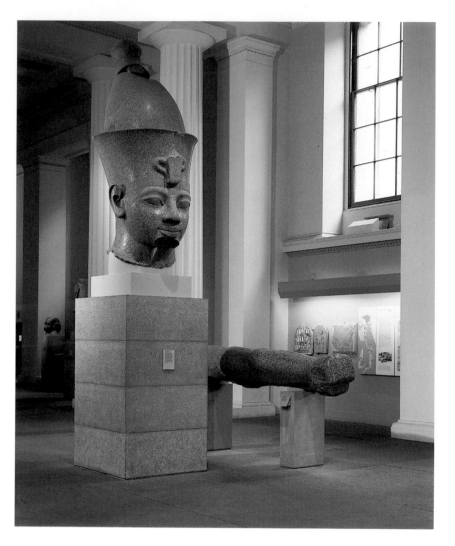

36 Royal head in red granite. The king represented in this colossal head is probably to be identified as Amenophis III. It belongs to a standing statue once set up in the temple of Mut at Karnak. The torso of the statue still lies near its original location (see fig. 10). Height 2.9 m. (no. 15)

first glance, it is well worthy of a more careful inspection. It is a pillared sandstone statue of King Amenophis I, the second king of the Eighteenth Dynasty (*c.* 1546 – 1526 BC) represented in the guise of the god Osiris (*fig. 38*). His arms, which are crossed on his chest, once held the traditional crook and flail, long since lost. On his head is the double crown of Upper and Lower Egypt. A great deal of the original paint survives. The king's names are inscribed on the back of the statue. It was discovered in the

temple of Nebhepetre Mentuhotpe at Deir el-Bahri, where Amenophis I is known to have carried out works of restoration. The statue's severely formal appearance recalls, perhaps deliberately, the sculpture of Mentuhotpe (compare the head, no. 720, in the side gallery), but the sensitive treatment of the facial features is thought more likely to have been inspired by late Twelfth-dynasty models (like the portraits of Sesostris III from the same site (nos. 684–6). This is the only intact statue of Amenophis I certainly identified by inscription and has therefore played a key role in studies devoted to the iconography of this king.

On the other side of the gallery are four statues of an exceedingly common type. Made of black granite and dated to the reign of Amenophis III, they represent the leonine goddess Sakhmet (*fig. 39*). Over six hundred such statues were set up by the king in his mortuary temple and in the temple of Mut at Thebes, where many still stand *in situ*. The British Museum has over thirty specimens in varying states of preservation, the largest single collection outside Egypt. Four of the best examples are displayed here (nos. 76, 57, 62, 80); another, usurped by a later king, in the northern section of the gallery (no. 517). There are two types, standing and seated. In both forms the goddess wears a moon-disc on the head and holds an *ankh*-sign, the symbol of life, in one of her hands. The standing figures hold additionally a sceptre in the form of a papyrus plant. The benign expressions on the leonine faces belie the nature of the goddess as a fierce protective deity; one of the seated figures bears an inscription in which the king is described as 'beloved of Sakhmet who smites the Nubians'. Another of the great gods patronised by Amenophis III was Thoth, the god of wisdom and writing, who is represented as a seated baboon, one of his most common manifestations, in the quartzite statuette just beyond the Sakhmet figures (no. 38). The god's cult centre was at Ashmunein (Hermopolis Magna) in Middle Egypt, where Amenophis III erected a number of enormous baboon statues of quartzite, identical in pose and style to this smaller piece.

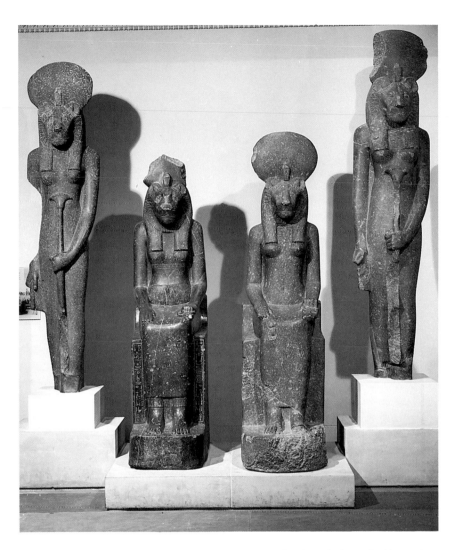

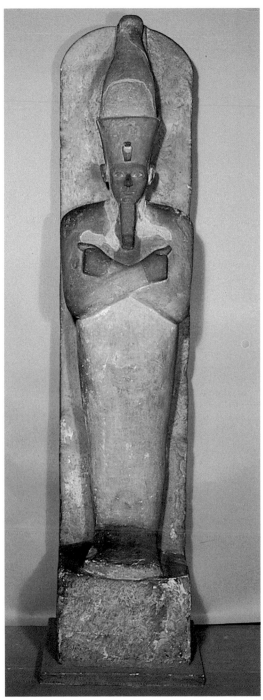

38 *right.* Sandstone statue of Amenophis I from Deir el-Bahri, Thebes. The king, whose name is inscribed on the back-pillar, is shown in the guise of the god of the dead, Osiris. His hands, crossed over his chest, once held the characteristic crook and flail. Height 2.69 m. (no. 683)

39 *above.* Four statues in black granite of the leonine goddess, Sakhmet, from Thebes. A huge number of these statues was set up in the mortuary temple of Amenophis III and in the temple of Mut at Karnak, to where they may have been moved at a later date. It has been suggested that their original total was 730, two for each day of the year. Height 2.36, 2.06, 2.18, 2.28 m. (nos. 76, 57, 62, 80)

The Central Saloon

The middle of the Central Saloon is occupied by four cases containing a selection of the finest small antiquities in the collection. Arranged around them, on open exhibition, is a series of larger stone sculptures, some colossal in scale dating mostly to the Eighteenth Dynasty. For the purposes of this guide, the sculpture will be treated first, beginning in the south and moving in a clockwise direction.

Elevated above the cases in the middle is a sandstone head of a king (no. 1238). Long attributed to Psammetichus II (c. 595 – 589 BC) of the Twenty-sixth Dynasty, it is now recognized on stylistic grounds to be much earlier, probably dating to the early Eighteenth Dynasty. It has recently been suggested that it represents King Tuthmosis I (c. 1525 – 1512 BC), of whom little sculpture survives and whose iconography has yet to be fully established. If the identification is correct, a possible source for the head is the temple of Karnak, where this king erected a number of Osiride statues of sandstone, several of which are now headless. Flanking the head on a lower level are two fine private block-statues of black granite, one belonging to Sennefer (*fig. 40*), the other to Amenhotpe (no. 632). They date to the reigns of Tuthmosis III and Amenophis III respectively, the portraits in each case reflecting the contemporary royal models. The difference in date is also reflected in their costume, in particular in their wigs, the later being more elaborate than the earlier.

Most of the early collectors of Egyptian sculpture were interested only in the fine and the exhibitable. Heads or the upper parts of statues were highly prized, while the bodies, from which the heads were often separated, were liable to be disregarded and their locations left unrecorded. Mention has already been made of the rediscovery of the body of the colossal red-granite head (*fig. 10*). Another piece in the collection for which an important 'join' has recently been achieved is the limestone queen wearing the so-called Hathor-wig (*fig. 41*). The piece is known to have been found by Belzoni in 1817 at Thebes, but there has been great uncertainty about its exact provenance and the identity of the queen. The missing bottom has

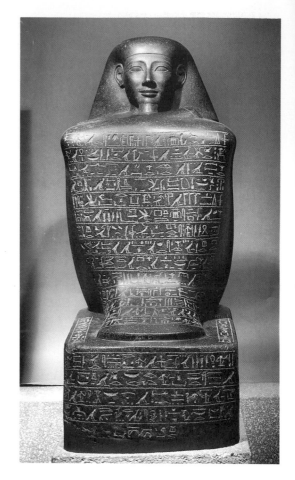

40 *above*. Squatting figure in black granite of Sennefer. The modelling and finish of this piece, which is dateable to the reign of Tuthmosis III, is very much in the style of the contemporary royal sculpture. It illustrates how well the block-statue was suited to the accommodation of long inscriptions. Height 83.8 cm. (no. 48)

41 *right*. Upper part of a limestone statue of a queen from Thebes. The bottom of this statue has recently been located in the temple of Karnak and bears an inscription identifying the owner as Ahmes-Merytamun, the wife of Amenophis I. She is shown wearing the so-called Hathor-wig. Height 1.11 m. (no. 93)

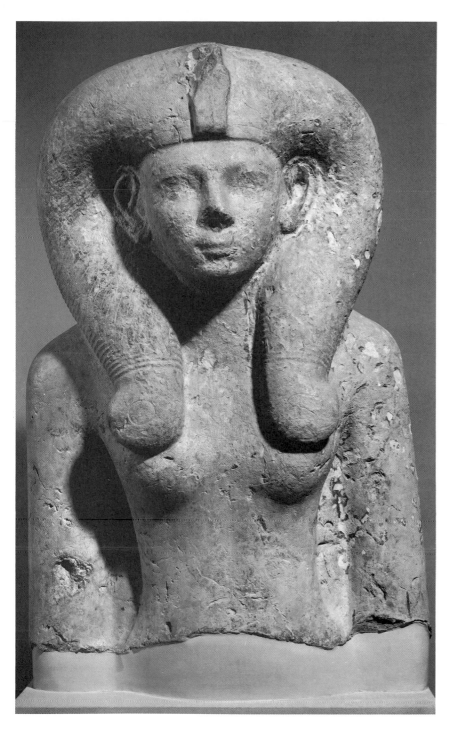

now been located in the temple of Karnak and it bears an inscription which identifies the owner as Queen Ahmes-Merytamun, the wife of Amenophis I.

Another large female head of limestone (no. 948) occupies the north-west corner of the saloon. It is not as well preserved as the other but was originally a much finer sculpture. It is one of several pieces in this area of the gallery to come from the mortuary temple of Amenophis III and it undoubtedly dates to his reign. The style of representing the facial features strongly recalls that of the king, as may be seen by comparing the features of this piece, most notably the eyes and mouth, with those of the nearby limestone statue of the king himself (*fig. 42*), which comes from the same site. The nature of the wig worn by the lady indicates that she is probably a goddess rather than a queen. In all likelihood she was once part of a group-statue, showing the king in company with a deity or several deities.

Arranged between these two large female figures are a number of private sculptures, outstanding among which is a limestone dyad or pair-statue (*fig. 43*) of a man and his wife. The piece is uninscribed and may therefore never have been fully completed, though it is possible that it was once finished in paint, now lost. The owners' elaborate coiffures and pleated costumes, subtly revealing the contours of the bodies beneath, date the piece to the late Eighteenth Dynasty (*c.* 1350 BC). Dyads of this kind showing husband and wife holding hands are common, but this statue has a human quality to it rarely encountered elsewhere. The couple await their eternity together in repose and contentment and with a quiet dignity.

In addition to the continued use of the more traditional types of private statue, the New Kingdom also saw the introduction of new forms. Prominent among these was the kneeling figure holding before it a stela or shrine or some cult-object. Several such figures are displayed in the Sculpture Gallery, the finest of which is probably the stelophorous (stela-bearing) statue exhibited next to the dyad, expertly modelled in an attractive purple quartzite (*fig. 44*). The

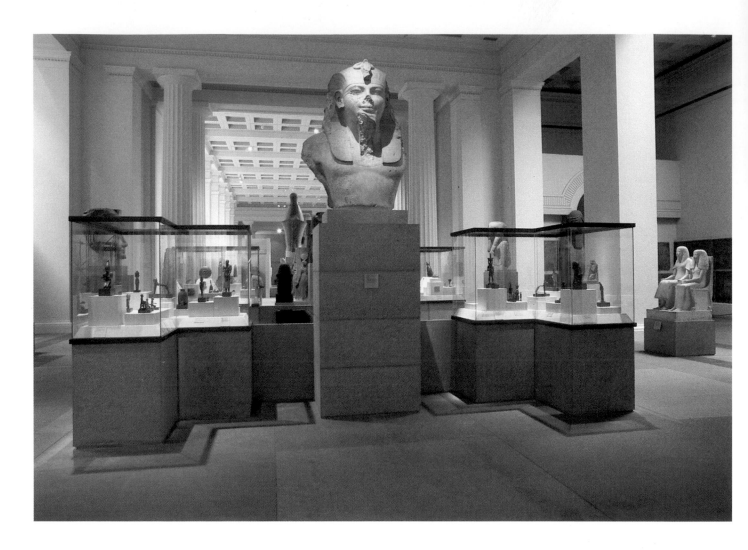

42 View of the Central Saloon from the north, with the colossal limestone bust of Amenophis III in the middle. Height 1.5 m (no. 3)

owner of this handsome little piece was a priest named Amenwahsu. He is shown in an attitude of worship, his hands held up open before him, his stela, as was the convention with such figures, inscribed with a prayer to the sun-god. Surmounting the text is a vignette which depicts the god, in the form of Re-Harakhty, astride his sacred bark. The date of the sculpture is a little problematic. This Amenwahsu has been identified with a dignitary so-named and with the same priestly titles who served under Ramesses II of the Nineteenth Dynasty. The man's portrait,

however, is rather Tuthmoside in style. If the proposed identification is to be sustained, its style must be explained as an attempt at deliberate archaizing, following closely mid-Eighteenth Dynasty models. Certainly Ramesside in date, however, is the curious limestone figure on the other side of the dyad (no. 1198). It is a type of statue known as an 'ancestor bust'. Such figures were set up in niches in houses and in tombs, their function, it has been suggested, to commemorate the dead members of a family. This specimen belongs to a lady named Mut-

43 *below.* Limestone pair-statue of a man and his wife. The piece has the appearance of being unfinished, though it may have been completed in paint, now disappeared. The lack of inscription leaves the owners unidentified, but their elaborate style of dress dates them to the late Eighteenth Dynasty. Height 1.32 m. (no. 36)

44 *right.* Quartzite stelophorous statue of Amenwahsu. This is a very fine representative of a type of figure which first appears in the Eighteenth Dynasty. The owner is shown in an attitude of worship, the stela in front of him bearing a prayer to the sun-god. Height 56 cm. (no. 480)

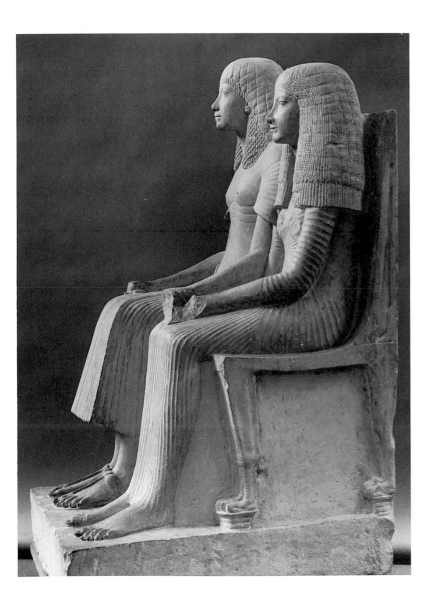

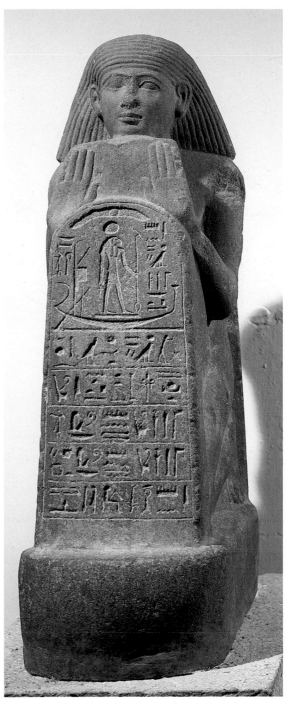

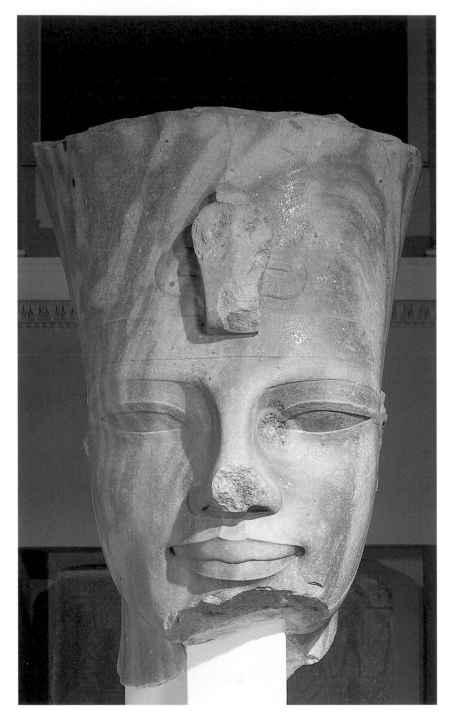

emonet and comes from the Theban tomb of her son, a well-known scribe in the reign of Ramesses II, called Amenmose.

On the eastern side of the saloon are exhibited four royal heads, all of the Eighteenth Dynasty. The one of black granite is unidentified (no. 526), the problems of attribution exacerbated by damage to the diagnostically crucial areas of the nose, mouth and eyes. There can be no doubt that the others represent Amenophis III (nos. 7, 119, and 6), whose iconography is one of the most individual and easily recognizable of all Egyptian kings. The traits of his portraiture are especially accentuated in the two larger, quartzite heads, both from his mortuary temple (nos. 6 and 7, *fig. 45*). Foreshadowed in these sculptures, with their elongated faces, full lips and narrow eyes, are the stylistic exaggerations of the art of his successor, Akhenaten (*c.* 1379 – 1362 BC).

45 *left*. Quartzite head of Amenophis III from Thebes. The distinctive traits of this king's portraiture are more than usually accentuated in this colossal head, one of a pair found in his mortuary temple. Height 1.17 m. (no. 6)

46 *right above*. Wooden cosmetic dish. The handle of the dish is in the form of a swimming girl, while the container is shaped like a duck, a favourite design-combination in such implements. Length 26.8 cm. (no. 38186)

48 *right below*. Bronze votive group of king and bull. The king, who is unnamed, is shown kneeling before the sacred Apis-bull, his hands held before him in a gesture of offering. The group was dedicated by a certain Peftjawemawyhor, who is named on the bull's pedestal. Height of bull 12.5 cm. (no. 22920)

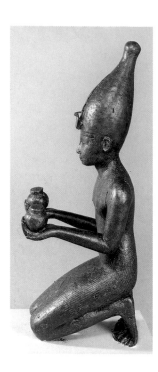

47 Bronze figure of Pimay. The king, who wears the white crown, is shown in a kneeling posture, holding before him two offering-pots. He is identified by the cartouches on his shoulders as Pimay, an obscure king of the Twenty-second Dynasty. Height 25.5 cm. (no. 32747)

Turning to the central cases, the visitor will observe that the two southernmost cover a variety of subjects – cosmetic objects, jewellery, statuettes, ritual objects, tiles – and a range of media including faience, ivory, wood, bronze, gold, silver, and other precious and semi-precious materials. The northernmost are devoted entirely to bronze figures. Only a small number of individual pieces can be singled out for mention here.

Among the jewellery, some particularly exquisite items include a gold openwork plaque (no. 59194) showing King Ammenemes IV of the Twelfth Dynasty offering unguent to the god Atum (c. 1795 BC); two gold spacer-bars (nos. 57699–700) embellished with recumbent cats and inscribed on the back with the names of Queen Sobkemsaf and her husband, King Nubkheperre Inyotef of the Seventeenth Dynasty (c. 1650 BC), whose coffin is displayed in one of the upper Egyptian galleries; and a pair of gold bracelets (nos. 14594–5) with inlay of semi-precious stones made for Prince Nemareth, son of King Sheshonq I of the Twenty-second Dynasty (c. 940 BC). Also worthy of note is the solid-gold signet ring of Sheshonq (no. 68868), the Chief Steward of the God's Adorer, Ankhnesneferibre (c. 570 BC). Fine sculptures in wood and ivory from tomb and temple contexts have already been encountered in the Old Kingdom section of the southern side-gallery. The same attention to detail and delicacy of execution can be seen here in examples of applied art, in the same materials, from the Middle and New Kingdoms: the figure of a servant girl carrying a chest on her head (no. 32767), once part of a cosmetic container (c. 1400 BC); a duck-shaped cosmetic dish (fig. 46) with handle in the form of a swimming girl (c. 1250 BC); and a masterful miniature in ivory (no. 54678) showing a king in the form of a sphinx clutching a foreign enemy in his paws (c. 1850 – 1700 BC), which may have functioned as the knob of a box. Glass and faience subjects are most appealingly represented by the famous polychrome cosmetic vessel in the form of a fish (no. 55193) from El-Amarna (c. 1350 BC), and by the Middle Kingdom hippopotamus figures (c. 1900 BC), both large

and small (nos. 35044 and 59777), their blue-glaze base decorated with floral motifs in black, a combination repeated in a splendid faience dish (no. 4790) of the Eighteenth Dynasty (c. 1450 BC).

Among the metal figures, royal and divine subjects predominate and these date mainly to the Late Dynastic Period (c. 1085 – 342 BC), when such figures were commonly donated to temples and shrines to serve as votive statues for their dedicators. Most of the major gods of Egypt are represented here, such as Amen-Re (no. 60006), Osiris (no. 11054), Isis (no. 34954) and Ptah (no. 25261), as well as some of the less familiar ones, such as Iah (no. 12587) and the Soul of Pe (no. 11498). The most striking figure is the large seated cat (fig. 13), the sacred animal of the goddess Bastet, with gold nose- and ear-rings and silvered pectoral, one of the finest examples (no. 64391). Royal figures are usually represented in a kneeling posture, their arms held before them, sometimes holding two offering-pots. An exceptionally important specimen is the one inscribed for King Tuthmosis IV (no. 64564) of the Eighteenth Dynasty (c. 1420 BC), which is the earliest known example of this type of figure in metal. Also remarkable is the larger figure (fig. 47) wearing the white crown, which is inscribed for Pimay, an obscure king of the Twenty-second Dynasty (c. 770 BC), of whom very few monuments survive. In their original setting, these kings knelt before the larger figure of a divinity, as illustrated by a group (no. 22920, fig. 48) in which a king, who is unnamed, makes a gesture of offering before the sacred Apis-bull (c. 600 BC). An inscription on the pedestal names the dedicator of the group as a certain Peftjawemawyhor, for whom benefits from the deity are invoked. The outstanding private bronze on display is the large standing figure of Khonsirdais (no. 14466), a priestly official under Psammetichus II (c. 630 BC), which is quite elaborately detailed. The priest, dressed appropriately in a leopard-skin costume, once held before him a small statuette of a god, probably Osiris. A scene on his skirt shows him venerating Osiris, and a figure of the same god is incised on his right shoulder.

The Northern Sculpture Gallery

To pass from the Central Saloon to the northern part of the Sculpture Gallery is to leave an area dominated by sculpture of the Eighteenth Dynasty for one in which, to begin with, royal sculpture of the Nineteenth Dynasty is dominant. A huge bust of a king (front cover) occupies the centre of the gallery, rising high on its plinth, but not as high as it would have been in its original setting. Ramesses II is the king, and the sculpture comes from his mortuary temple in Thebes, known as the Ramesseum. It was perhaps the first piece of Egyptian sculpture to be recognized as a work of art in modern times by connoisseurs accustomed to judging everything by the 'supreme' standards of Greek art. W.R. Hamilton in 1809 declared it to be 'certainly the most beautiful and perfect piece of Egyptian sculpture that can be seen throughout the whole country'; an attempt had earlier been made during the Napoleonic expedition to remove it from Thebes; but it was the engineering skill of Belzoni which succeeded in 1816. On the commission of J.-L. Burckhardt and Henry Salt, he brought it down from Thebes and arranged for its transport to London, where it was put on exhibition in 1818 under the name of 'Younger Memnon'.

It has never been established whether the original statue showed Ramesses standing or seated on a throne; it is evident, however, that the ancient viewer, standing near the statue, would have had to elevate his eyes considerably to see the face; here, as with other colossal statues, the ancient sculptor made a compensatory adjustment to the setting of the eyes, so that the royal gaze is directed not straight ahead, as was normal in Egyptian sculpture, but downwards. The same adjustment can be seen on the colossal royal head in the southern part of the gallery (fig. 36, no. 15). In another respect the ancient sculptor achieved an unusual effect. The slab of granite selected for this statue is of two colours, and this variation had been cleverly exploited to distinguish between the head and the rest of the body. For a sculpture on such a large scale it displays a remarkable sensitivity in the carving, presenting Ramesses with a serenity, perhaps unsuitable for his worldy reputation as the great conqueror, but appropriate for his eternal image in the after-life.

To his left Ramesses looks down on two pairs of royal sculptures on smaller scales, three of himself and one of Sethos II, a later successor of his in the Nineteenth Dynasty. The two Ramesses statues in red granite both come from cult temples, but are otherwise very different from each other. One shows the king wearing the double crown of Upper and Lower Egypt, and holding the crook and flail, the traditional instruments of royal power (fig. 49). It comes from the temple of the Nile-cataract deity, the ram-headed Khnum, on the Island of Elephantine, and it was presented to the Museum in 1838 by the same W.R. Hamilton who had perspicaciously noted and praised the Younger Memnon thirty years earlier. As a royal portrait it is less distinguished than its companion, also of granite (no. 1066), which came from the temple of the cat-goddess Bastet at Bubastis. Here Ramesses is shown wearing a short wig of a kind much favoured by Ramesside kings; it is also found on the adjacent statue with the double crown perched on top. The royal features in the Bubastite statue are much fuller and more rounded than is usual with representation of Ramesses II; the effect is to soften the appearance and produce a bland, self-satisfied look. By his side the king holds a staff which was originally mounted with a cult-figure.

The third of the smaller figures of Ramesses II is a good but very conventional limestone kneeling statue of the king holding a table of offerings (no. 96). Its companion is of much greater interest, a light-coloured quartzite seated figure of King Sethos II (fig. 50) holding on his knees a small shrine topped with a ram's head, the ram being one of the theophanies (physical manifestations) of Amun, the great imperial god of Thebes. Belzoni, who discovered it in Karnak, understandably, but erroneously, identified it as an image of Jupiter Ammon. The piece has a cold perfection, displaying remarkable competence in the working of a very hard stone – a triumph of traditional craftsmanship and technique in a period (the late Nineteenth Dynasty) which has left little sculpture of quality.

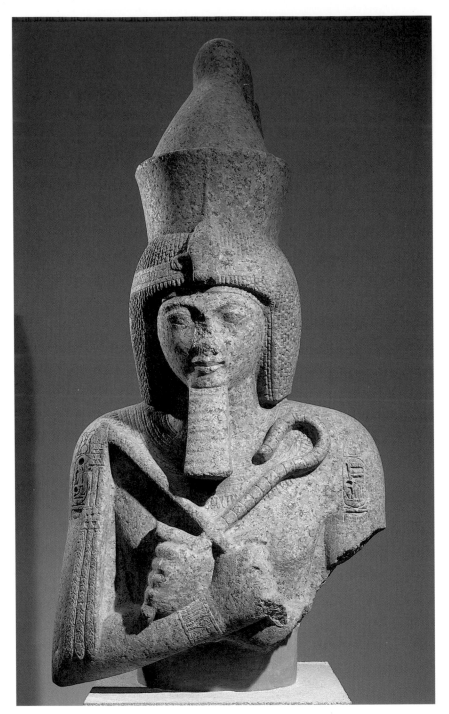

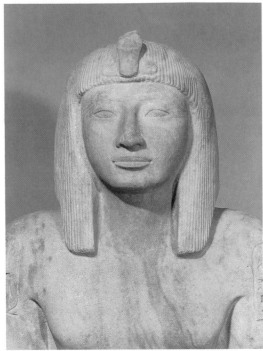

49 *left.* Upper part of a granite figure of Ramesses II. He is shown wearing the double crown of Upper and Lower Egypt, and holding the crook and flail, the insignia of royalty. Height 1.43 m. (no. 67)

50 *above.* Head of a quartzite life-sized figure of Sethos II. Height of complete statue 1.66 m. (no. 26)

51 *right.* Head of a black granite royal statue with the attributes of the Nile-flood deity, Hapy. It is inscribed with the names of Horemheb, last king of the Eighteenth Dynasty, but preserves the features commonly associated with Tutankhamun. Height as restored 1.68 m. (no. 75)

Particularly striking is the naturalistic modelling of the legs.

Another unusually fine piece from an otherwise indifferent period is placed on the open floor of the gallery near the two granite statues of Ramesses II. It is a huge granite block bearing a sunk-relief representation of the King Osorkon II with his wife Karoma engaged in an act of homage before an unidentified deity (no. 1077). The block formed part of a massive gateway carved with scenes relating to the king's jubilee celebrations in the temple at Bubastis, from which one of the Ramesses statues also came. While the presentation of the scene is a little wooden, it admirably illustrates in the excellence of its execution the long-lasting influence of well-established tradition and convention.

Across the gallery, on the west side are sculptures and inscriptions of King Horemheb whose reign bridged the years between the end of the Amarna Period and the beginning of the Nineteenth Dynasty (c. 1348 – 1320 BC). A double statue of grey granite shows the king at small scale by the side of the god Amen-Re (no. 21), here depicted as an ithyphallic god of fertility, associated with the god Min, and given the appropriate epithet 'Bull of his mother'. Unfortunately the head of the king is lost, and there is therefore no possibility of judging whether or not the statue was carved with the features conventionally expected for Horemheb. Many statues and relief representations of the king, identified by inscriptions, can be shown to be usurpations of 'portraits' originally intended to be of Tutankhamun.

The usurpation of royal sculptures was by no means uncommon for a variety of reasons, including malice, and the wish to make use of the work of a predecessor for economical reasons. Some usurped statues, in particular, are pieces which were left unfinished at the death of one king, and, again economically, made use of in the subsequent reign. Such seems to have been the case with the second granite statue which shows a king holding in front of his body an offering table from which hangs down in festoons the multifarious produce of the country; here the king represents the god

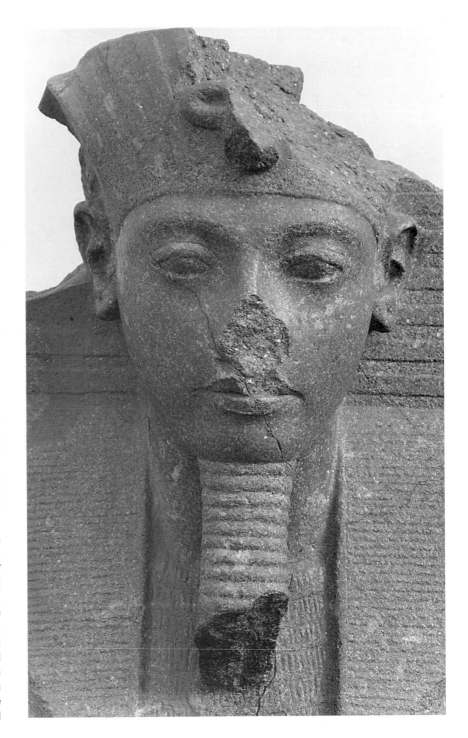

of the Nile-flood, Hapy, and he is identified in the inscription on the back pillar as Horemheb (no. 75). There is no sign that this inscription has been altered; yet the royal features are those usually associated with Tutankhamun, whose reign preceded that of Horemheb, separated only by the four years of the ephemeral king Ay. Although the head is damaged, it can be seen to be a remarkably fine carving of great sensibility (*fig. 51*), highly reminiscent of the most famous of Tutankhamun portraits, that of his gold funerary mask. Something of the same likeness can be seen in the head of Amen-Re in the adjacent pair-statue, where, however, the similarity may be a stylistic legacy from the immediately preceding period.

Horemheb did not belong to the royal line of the Eighteenth Dynasty, and in his early career he was Tutankhamun's general. As a private, but very important person, he had a large tomb constructed for himself at Saqqara. It was decorated with scenes of the finest relief-carving, and with inscriptions of which three are shown on the west wall of the gallery behind the two sculptures of the king. Two door-jambs (nos. 550, 552) show Horemheb in attitudes of adoration, with prayers addressed to the mortuary deities (no. 550) and to the sun-god Re (no. 552). The large, round-topped inscription (stela) in the middle (no. 551) bears another long hymn addressed to the sun-god, in twenty-five lines of fine, but not elaborate hieroglyphs. In the scene above, Horemheb bends forward in adoration of the deities Re-Harakhty, Thoth and Maat. The carvings of Horemheb and the gods on these slabs demonstrate the return to the tradition of relief-sculpture so highly developed in the reign of Amenophis III, which was abandoned during the reign of Akhenaten; it achieved its apogee during the reign of Sethos I. The less formal reliefs on the walls of the courts of Horemheb's tomb (only recently rediscovered at Saqqara), contain a wonderful mixture of the old formal style and the free, expressive, manner of the late Amarna Period. On both door-jambs Horemheb's head has been modified by the addition of the royal uraeus-cobra, a change made after he became king, and possibly after his death, in recognition of the royal cult.

Ramesses II's most famous son, and his crown-prince for the greater part of his reign, was Khaemwese. He served as the vizir in the north of the country, the most important and influential secular office in Egypt during the New Kingdom. Such was his fame during his life-time that he was remembered for a thousand years after his death, and credited with great wisdom and supernatural powers in romances of the Graeco-Roman Period. In his own time, however, he was represented in the customary convention of a non-royal person, and as such he is shown in the statue which stands to the left of the great bust of his father, the 'Younger Memnon'.

This statue of Khaemwese (*fig. 52*) deserves close examination. It is carved in an extremely hard conglomerate which, in its uncarved block undoubtedly looked a fine prospect for the sculptor, with beautifully varying colour and fine texture. What was not apparent was the pebbly inner core; this unexpected sculptural hazard was tackled with determination by the craftsman, and while he had partial success in the area of the chest, he was defeated around the neck and chin, and whole pebbles had to be prized out of the main stone, or matrix, probably to be replaced with plaster. Repairs with plaster and separate stone insertions can also be seen in the inscribed back-pillar.

How less fortunate was the sculptor of this statue than those who worked on the 'Younger Memnon' and were able to exploit the bi-coloured stone of that piece to such good effect! And yet the Khaemwese is also a triumph. Apart from the blemished areas it is splendidly carved; the limbs are modelled with great subtlety, and the head with a precision which enhances the sensitivity of the sculptor's observation. This sculpture was probably placed in a temple at Abydos, the great cult-centre of Osiris in Upper Egypt. Khaemwese holds two cult staves – one supporting a strange vessel associated with the Osiris cult, the other a group of three figures, now mostly destroyed, probably representing the divine family group, or triad,

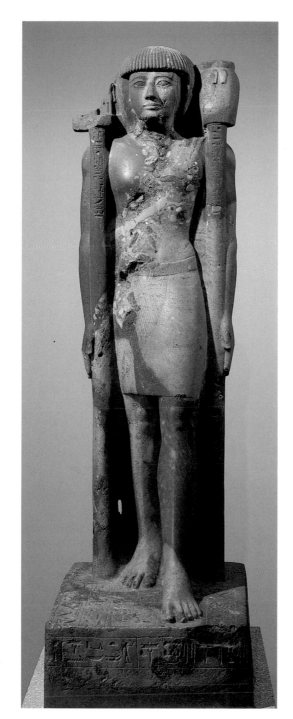

52 The northern vizier of Egypt, Khaemwese, a son, and for a time the crown-prince, of Ramesses II. The conglomerate stone of which the statue is made proved very difficult for the sculptor to carve. Height 1.46 m. (no. 947)

of Osiris, Isis and Horus.

Beyond Khaemwese and the 'Younger Memnon' a ramp rises up to a raised area which corresponds with the similar area in the southern part of the gallery and leads into another side gallery. The route followed here does not allow a strictly chronological progress; it will include in irregular order objects of the New Kingdom, the Late New Kingdom (the Twenty-first to Twenty-fourth Dynasties, *c.* 1085 – 715) BC), the Nubian and Saite Dynasties (Twenty-fifth and Twenty-sixth, *c.* 747 – 525 BC), the last Pharaonic Dynasties (Twenty-seventh to Thirtieth, *c.* 525 – 343 BC), and the subsequent Graeco-Roman Period. At the bottom of the ramp, on the right, sits the unusual block-statue of Roy (*fig. 3*), a High Priest of Amen-Re in the reign of Ramesses II, in which the articulation of the limbs is much more pronounced than is commonly the case with such statues. The whole piece radiates authority, properly reflecting the status of its subject, while the head presents Roy as a man of stern and commanding presence.

The two sculptures which claim most attention as the ramp is ascended are both of Nubian origin: a large ram and a sphinx of different coloured granites incorporating images of Taharqa, the fourth king of the Twenty-fifth Dynasty, (690 – 664 BC), from the temple he built at Kawa, south of the Third Cataract of the Nile in Nubia. The Nubian or Kushite kings who invaded and ruled Egypt as the Twenty-fifth Dynasty were prompted to their action chiefly (as they themselves maintained) by the desire to re-establish the worship of the Theban god Amen-Re which (as again they maintained) had fallen into neglect in Egypt itself. The cult of Amen-Re had originally been introduced into Nubia during the New Kingdom, and had survived and prospered at Napata, the centre of Kushite power in the interim. The ram was, as already pointed out, one of the theophanies of Amen-Re, and in the figure from Kawa (no. 1779) it is represented sitting majestically with head raised high, and a small image of Taharqa placed protectively between the flexed front legs. This small figure of Taharqa is insignificant in the shadow of the divine animal, and it

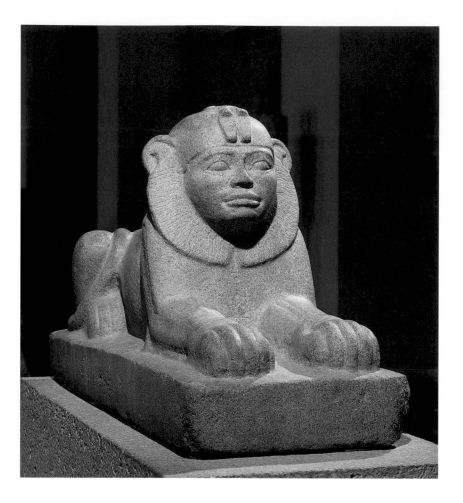

53 Granite sphinx with the features of King Taharqa. The double uraeus on the brow is characteristic of the royal insignia of the Kushite kings. Height 42 cm. (no. 1770)

displays none of the striking force, perhaps even barbaric power (as some claim) of the head of the sphinx, which also represents Taharqa (*fig. 53*). The king as a sphinx, destroying his foreign enemies, was an image employed by Taharqa in the reliefs of his Kawa temple, copied closely from Egyptian originals of the Old Kingdom. This small sphinx also has strong connections with Middle-Kingdom Egyptian originals in which the raised ruff of hair around the lion's neck is emphasized.

Another, but very different, monument of a Twenty-fifth-dynasty king is mounted on the east wall of the main gallery, and viewed from the raised area. This is a large basalt slab covered with a lightly carved inscription (no. 498), much of which was destroyed in late antiquity or medieval times when the slab was used as a nether mill-stone. The inscription represents ostensibly the rescue from oblivion by King Shabaka (*c*. 716 – 702 BC) of an ancient document containing a dramatic composition embodying the theological system of Ptah, the great god of Memphis. According to the preamble, the old document was tattered and worm-eaten in Shabaka's time, and he ordered its transcribing on stone as an act of piety towards the gods of Memphis. It is now thought that the account of the rescue is an ancient fiction, but that the text still incorporates much of what was theologically ancient in Shabaka's time, and that it undoubtedly represents a pious attempt by Shabaka to secure the support of the influential priesthood of Memphis. The language of the text is a good attempt at religious Egyptian of the Old Kingdom, while the lay-out of the so-called copy on the slab is a brave attempt to copy the form of early documents.

The Shabaka Stone, as this great slab is generally called, is flanked by two good, though not exceptional pieces of non-royal sculpture of the Twenty-sixth Dynasty, the more interesting of which (no. 1132) represents Nespaqashuty, Theban vizir of Psammetichus I (664 – 610 BC). Nespaqashuty holds a sistrum, the cult-object of Hathor, in front of him, and he wears a double wig of a kind common in the Eighteenth

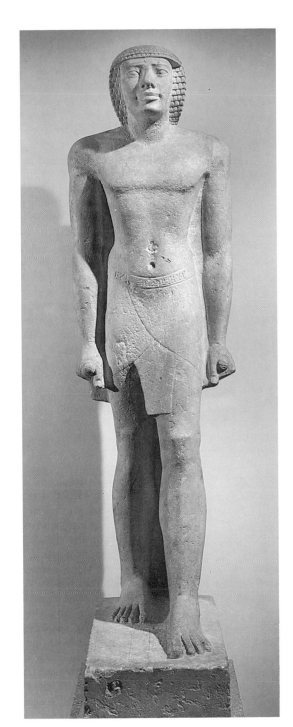

54 The high official Tjayasetimu. In pose and style this limestone statue recalls the tomb statues of the Old Kingdom. Height 1.26 m. (no. 1682)

Dynasty and subsequently in the New Kingdom, and revived in sculptures of the Twenty-fifth Dynasty, a good example of the archaising tendency in Late-period sculpture. This statue is of further interest in that it is made up of two pieces, upper and lower, which came into the British Museum at different times, and from different sources. The pieces were united through the independent researches of the leading modern students of Egyptian sculpture of the Late Period. The archaising tendency found in this piece is also exhibited in the adjacent standing limestone statue of Tjay-asetimu (*fig. 54*), which is based on the conventional standing mortuary figure of the Old Kingdom, the best example of which in the Museum is that of Nenkheftka (*fig. 20*). The attenuating appearance of the later piece is due to the application of a modified canon of proportions for artistic purposes introduced in the Twenty-sixth Dynasty; where the older and traditional canon made use of eighteen squares for the height of the standing figure, the new canon employed twenty-one.

The higher level of the raised area allows the visitor to look down into the interiors of two huge stone sarcophagi which stand on either side of a short flight of steps leading to the main level of the gallery. The larger of these two sarcophagi was carved for Nectanebo II (no. 10), the last king of the Thirtieth Dynasty, and the last native ruler of Egypt in antiquity (360 – 343 BC). Its outside is covered with inscriptions carved in small, neat hieroglyphs, consisting of sections of the funerary composition known as *The Book of what is in the After-world*, one of the texts used in the great Theban royal tombs in the Valley of the Kings during the New Kingdom. The precision of the shaping of the huge monument and in the carving of the inscriptions is the more to be marvelled at because the stone of which it is made is an exceptionally hard conglomerate, or breccia, of very varied colour. It must be presumed that Nectanebo was buried in this sarcophagus and that his tomb was violated some time after the invasion of Alexander the Great in 332 BC. At a later date it was transported to Alexandria

where it was installed as a public bath. Holes were drilled on a level with the inside bottom to allow the water to be removed. This misuse led to the substantial effacement of the texts and divine representations on the inside. In the original burial, a series of wooden coffins of diminishing size held the royal body. When this great monument was brought back to the Museum in 1803, its royal association was correctly divined, but it was wrongly thought to have been made for Alexander the Great.

The second huge sarcophagus (no. 32) is even more remarkable than that of Nectanebo. It was made for the Princess Ankhnesneferibre, daughter of Psammetichus II, who held the immensely important position of God's Adorer of Amun in Thebes from 584 to 525 BC. The God's Adorer of Amun was virtual ruler of the Theban principality throughout the Twenty-fifth and Twenty-sixth Dynasties, and she was allowed a burial and a tomb worthy of royalty. Ankhnesneferibre's tomb also was violated and the sarcophagus was usurped by Pimentu, a priest of the god Monthu, during the early Roman Period. It was made of schist, and carved, inside and outside, with funerary inscriptions derived from the Pyramid Texts which had been first used in the pyramids of the kings of the Fifth Dynasty, almost two thousand years earlier. The hieroglyphic signs are most beautifully formed and most accurately carved, demonstrating the skill of the ancient craftsman at this late period in working very hard stones. An elegant figure of the goddess of the West, a form of Hathor, can be seen on the floor of the coffer. Its lid, happily preserved, is mounted vertically in a niche within the side gallery to the east of the main gallery, but it can be seen from the main gallery through a sandstone doorway belonging originally to a small temple at Karnak, dedicated by Ankhnesneferibre. The lid, with its fine relief figure of the princess, will be considered later, in its order in the side gallery.

The sandstone doorway (no. 1519) carries small scenes of a ritual character including Ankhnesneferibre herself, the king Psammetichus III, and her major-domo Sheshonq. In her long tenure of office she had two major-domos named Sheshonq; the one shown here is Sheshonq, son of Pedineith. The other Sheshonq, son of Harsiese, served Ankhnesneferibre at the outset of her reign, and he was the dedicator of the impressive schist statue-group placed to the right of the doorway (no. 1162). This votive sculpture shows the goddess Isis standing in protective attitude, holding her wings around a smaller figure of Osiris, represented, as usual, as a mummiform figure. This is an outstanding example of the virtuoso carving of hard stone, being at the same time a notably impressive group sculpture, executed with great sensitivity. The same Sheshonq was the owner of a massive gold official signet on exhibition in a case in the Central Saloon (no. 68868).

From the head of the ramp leading to the raised area entry to the side gallery can be made. A group of animal and bird sculptures, figures of divine creatures, stands on the right, observing, it seems, the progress of the visitor who passes between two wooden figures of kings of the Nineteenth Dynasty, to be faced by a striking gilded coffin. The wooden figures (nos. 882, 883) were retrieved by Belzoni from the royal tombs in the Valley of the Kings at Thebes. They are slightly larger than life-size, and performed a guardian function after the manner of the two partially gilded wooden figures of Tutankhamun which stood sentinel over the sealed entrance to the burial chamber in his tomb. The gilded coffin (*fig. 55*) also came from a tomb in the Theban Necropolis, but its location is not known. It is the inner coffin of a pair, the outer one of which can be seen in the Second Egyptian Room upstairs; others parts of the same funerary equipment are also exhibited in the upper galleries. Henutmehit, the owner of the equipment, was a priestess of the god Amun, and she lived during the Nineteenth Dynasty. Nothing is known of her life, or of her family, but the high quality of her coffins suggests that she was well connected, and certainly well favoured. Her gilded inner coffin is a particularly fine example of the mummiform kind. It is of wood which has been carved with low relief representations of funerary deities,

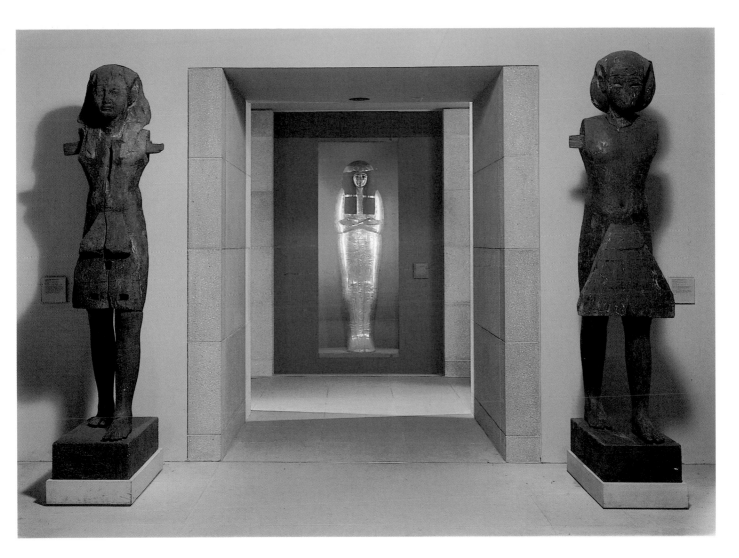

55 The entrance to the northern side gallery, flanked by two wooden royal statues from tombs in the Valley of the Kings (nos. 882, 883); within the entrance, the gilded inner coffin of Henutmehit. Height 1.88 m. (no. 48001)

then thinly plastered and covered with fine gold leaf. The form of the body, observed beneath its notional wrappings, is subtly suggested, while the face is most sensitively carved. The eyes are inlaid with glass to produce a convincingly lifelike effect. Such was the container of this priestess-singer of Amun; destined to be placed within another coffin, and not to be seen again after the burial was made. But it was probably made in the lifetime of Henutmehit, who could therefore have

inspected the work and ensured that her resting place in death would not fail in its purpose and do her discredit.

The south end of the side gallery is occupied by an imposing granite inscription (*fig. 56*, no. 826), the texts of which include an important development in the expression of personal piety in the years just before the religious revolution introduced by King Akhenaten. The monument, which takes the form of a large doorway with heavy cornice, was prepared for

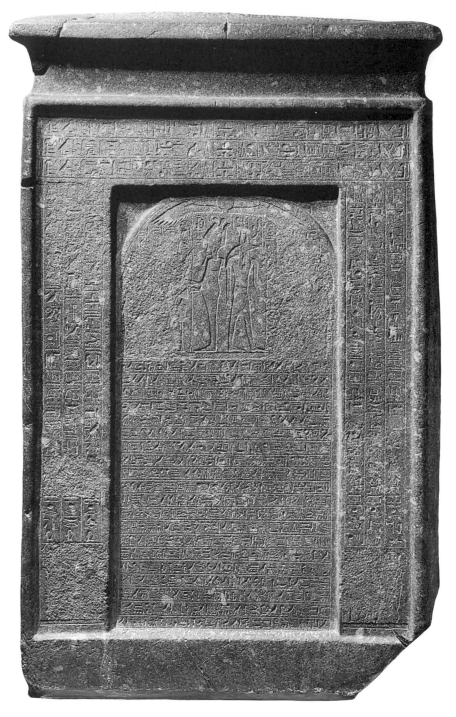

two brothers, Hor and Suty, who were both overseers of works of Amun in Luxor during the reign of Amenophis III (*c.* 1417–1379 BC). The most important part of the inscriptions occupies the area in what would have been the opening of the door. Prayers are addressed to forms of the sun-god, and one in particular to the Aten, the disc of the sun, which became the central object of worship under Akhenaten. There are, however, numerous deletions of figures and parts of the texts which lie on the lintel and two jambs of the doorway, and in the scene above the main inscription. The texts on the lintel are divided between Hor (right half) and Suty (left half); those on the right jamb are for Hor, and those on the left jamb for Suty. The figures of the two men, who were originally shown seated on chairs, at the bottom of the jambs, have been hammered out. Suty's jamb has suffered further damage in the hammering out of the invocations to the deities Osiris, Sokar and Isis, at the top, and of his own name in each of the three columns lower down. An attempt to hammer out Hor's name in the corresponding position on the right jamb was apparently abandoned. But in the scene in the middle, Hor and Suty, with their wives, were successfully deleted; originally they were shown making offerings to Anubis (right) and Osiris (left). In addition, in a number of places the name of the god Amun has been deleted and subsequently recut, the deletion being an act of malice during the reign of Akhenaten. But all the various deletions cannot be explained on the same grounds.

In the same area of the side gallery there are two small statues of special interest and a number of reliefs and inscriptions which require close attention (*fig. 57*). In front of the stela of Hor and Suty is the green schist statuette of King Ramesses IV of the Twentieth Dynasty (*c.* 1166 – 1160 BC); the front part of the figure has been restored, including the knees and the hands holding two pots which represent an offering of wine (no. 1816). Royal sculpture of the later Twentieth Dynasty is not common, but this piece demonstrates that good work could be accomplished from time to time. The head

56 *left.* Black granite stela of the two officials Hor and Suty. In the scene above the main inscription the figures of the two men and their wives have been deliberately defaced. Height 1.45 m. (no. 826)

57 *right* The south end of the northern side gallery; in the centre, the kneeling statuette of Ramesses IV (no. 1816); to the right, the begging quartzite figure of Pa-aha. (no. 501)

in particular is quite skilfully rendered in the conventional manner of the later Nineteenth Dynasty, and it possesses an appealing quality not much found in sculpture of the period. Even more appealing is the quartzite statuette of Pa-aha (no. 501) which is placed in the deep recess on the right of the Ramesses IV piece, and slightly to its rear. Pa-aha is shown squatting on the ground in the scribal attitude, although he holds no papyrus on his knees. He is, in fact, begging for offerings from the god, who is here Ptah, the great god of Memphis. In his supplication Pa-aha holds his right hand, cupped, to his mouth, while he supports with his left hand a narrow shrine containing an effigy of Ptah. Pa-aha's head is most sensitively carved in a style very reminiscent of late Eighteenth-dynasty private sculpture; this piece, however, is probably to be dated to the early Nineteenth Dynasty.

In the same recess with the statuette of Pa-aha are two striking pieces of relief. The first is an elegant sunk relief carving of the funerary deity Anubis, shown here in a typical attitude of guardianship, sitting on a shrine (no. 455). Anubis was regularly depicted as a jackal, the denizen of the desert and frequenter of cemeteries. Painted in bluish-black paint, wearing a yellow neck-band and a red 'tie' around his neck, and supporting a royal flail on his back, he raises his head in alert surveillance. The second relief is in sandstone and consists of the head and part of the headdress of the ram-headed god Khnum (no. 635). This again is a conventional representation of the god, but it is carried out in a bold high relief which allowed the sculptor to introduce a great deal of modelling in the carving of the head; the result is very striking, and wholly satisfactory.

On the wall opposite the recess is mounted a group of reliefs, mostly funerary stelae, which come from a part of the Theban Necropolis occupied in antiquity by the village and tombs of the skilled workmen who made and decorated the royal tombs in the Valley of the Kings. Although the workmen were not highly placed in the social system of ancient Egypt, they possessed many skills, and were able therefore

58 Limestone stela of Neferronpe and Neferabu; their mummies with those of their wives receive rites of 'reactivation' in the upper scene. Height 69.5 cm. (no. 305)

to provide for themselves funerary equipment of a high standard. The stelae are much less formal in their scenes and inscriptions than those of the great officials, which can be seen elsewhere in the gallery. All are worthy of close examination, but attention should specially be paid to one on the right, made for the workman Neferronpe and his son Neferabu (*fig. 58*). The scene in the upper register shows part of the funerals of the two men and their wives, presented as if they were all happening at the same time. The mummies of the four are placed upright, and the rite of 'opening their mouths' is taking place, which would enable the dead to eat and speak. Female mourners attend the funeral, stooping and putting dust on their heads. In the lower scene a mummy is depicted in a kiosk attended by a priest wearing a jackal-mask, impersonating the god Anubis. Smaller objects concerned with the life and burial of these workmen are exhibited in a wall-case to the left of the stelae. Of special interest is a large limestone flake, or ostracon (no. 5634), on which is written a register of attendances by workmen on the construction of the royal tomb, in this case that of Ramesses II. Days when each man was absent are noted, and the reasons for the absence, such as sickness, to brew beer, or to deal with domestic problems.

Beyond the gilded coffin of Henutmehit, further north in the side gallery is another wall-case containing three small statues in different materials, and of unusual interest. The first is of bronze (no. 43373), representing a woman, probably a high-stationed priestess, who originally held in her left hand a small shrine or divine emblem. Fine large bronze figures were first made during the Twenty-second Dynasty (*c.* 945–715 BC), a period when Egyptian art was, generally speaking, at a low ebb. The piece on display is unlikely to be of so early a date, and could perhaps be of the Twenty-fifth Dynasty. When it was made the bronze was covered with a thin layer of gesso-plaster and gilded; the surface of the bronze was deliberately left in a rough state so that the plaster would cling to the base. The loss of the plaster and gilding has

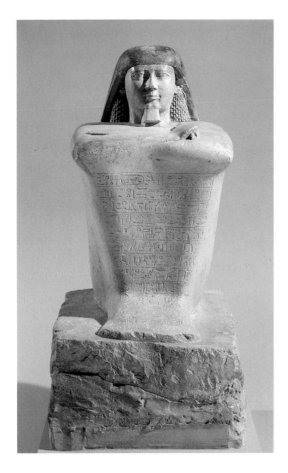

59 The official Iti shown in the form of a limestone block statue. The mass of the body tapers more sharply than is common from knees to feet. Height 46 cm. (no. 24429)

made the piece far less dramatic in appearance, but it does allow one to see the excellence of the basic bronze figure, to admire the moulding of the limbs, and to appreciate the skill of the bronze-casters. Traces remain of the original inlaying of the eyes, the effect of which would have given the head a most lifelike appearance.

The Twenty-fifth-dynasty date of the piece next to the bronze is without doubt. It is a block-statue of an official named Iti (*fig. 59*), who lived during the reign of King Shabaka of that dynasty. The inscription on the front of the statue is dated in the fifteenth regnal year of the king, which happened to be his last year (702 BC); and more precisely to the eleventh day of Payni, the second month of the flood season. This naming of the month (Payni) is the first recorded occurrence of the practice which was to become common only very much later. The statue itself is raised up on a poorly shaped base which probably fitted originally into a podium of some kind; its body is beautifully finished, while the head is very crisply carved in all its details – a result made possible by the very hard limestone of which the piece is made. It is shown wearing a double wig of the kind introduced during the Eighteenth Dynasty.

The third figure is of a priestly official holding a small effigy of the god Ptah in front of his body (no. 67138). It is a good, but not exceptional, piece of the Late New Kingdom, or a little later, but is a rare survival in wood of a type of sculpture of votive kind, which has been preserved in many examples in stone from the Late Period. Unfortunately it is uninscribed.

A deep niche in the opposite wall of the side gallery contains monuments connected with the Fourth Prophet of Amun, Mentuemhat, who was the principal officer of state in the Theban principality from the reign of Taharqa of the Twenty-fifth Dynasty (690 – 664 BC) to at least Year 14 of Psammetichus I of the Twenty-sixth Dynasty (650 BC). A great many statues of this man have survived from antiquity, some of which seem to represent him with convincing portraiture, except that no two of the apparent portraits are alike. The one statue in the British Museum is conventional in style; Mentuemhat is shown kneeling and holding a votive stela before his knees (no. 1643). The head of this granite piece is a little damaged, but it is evident that the features were modelled in an unadventurous manner, with no attempt at portraiture. This statue is flanked by two further granite monuments; on the left a massive offering table on a solid base, the surface carved with representations of various food offerings, and inscribed for Mentuemhat's son, Nesptah (no. 1485); and on the right a finely shaped offering bowl, with lugs carved with heads of the goddess Hathor, and an inscription around the rim invoking offerings for Mentuemhat himself (no. 1292). The most remarkable monument surviving from Mentuemhat's ancient

achievement is the great tomb he constructed in the Theban Necropolis. Its reliefs were copied from those in tombs of earlier periods, and one small fragment, brilliantly painted, is mounted on the wall behind the other pieces (no. 1518). It is part of a marsh-scene of the kind commonly found in the chapels of mastaba-tombs of the Old Kingdom, and, like its progenitors, is carved in limestone.

Mentuemhat served two God's Wives of Amun, Shepenupet II and Nitocris. The God's Wife Ankhnesneferibre, the last of the series, now returns to notice with the lid of her great schist sarcophagus (*fig. 60*), the coffer of which has already been seen in the main Sculpture Gallery. The lid is mounted opposite the reconstructed doorway of her Karnak shrine which can also be seen from the main gallery. The centre of the lid carries a large low relief figure of Ankhnesneferibre of very commanding presence. She is shown wearing the vulture headdress surmounted by high plumes and sun-disc between horns, the whole characteristic of the formal accoutrement of the God's Wife. In her hands she carries the crook and flail, traditionally the instruments of royal power, and here a clear indication of the status of her own power, at least as far as the Theban area is concerned. On her body she wears a long, pleated, loosely fitting gown, and on her feet elaborate sandals. Her head is rendered very forcefully, and, while she exhibits in this image little beauty or grace, it should be remembered that at the time of her death she had held office in senior and junior positions for almost seventy years. Nevertheless, the sculptor who carved this figure was a master in the techniques of carving schist, one of the hardest stones employed by the Egyptians, and succeeded admirably in suggesting the bodily forms of his subject below the flowing folds of her gown.

Towards its northern end, the side gallery widens and advantage has been taken of the greater depth to exhibit a large granite sarcophagus (*fig. 61*) as if it were in a vault of the kind found in tombs of the Late Period. No attempt has been made exactly to reproduce the architectural form of the ancient vault, but some-

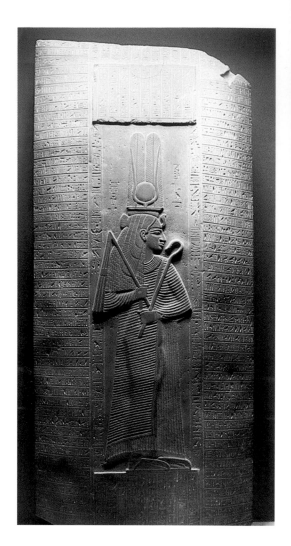

60 Lid of the schist sarcophagus of the God's Adorer of Amun, Ankhnesneferibre. The relief representation of the deceased shows her in the prime of life. Height 2.57 m. (no. 32)

61 The granite sarcophagus of Nesisut. Its domed lid incorporates a carving of a head intended to represent Nesisut. Length 2.47 m. (no. 30)

thing of its dark atmosphere is suggested. The sarcophagus, which is exhibited complete with its handsome lid, was prepared for the burial of a priest of Memphis named Nesisut, who lived during the Twenty-seventh Dynasty, the period of Persian domination in Egypt (525 – 404 BC). Both sides of the coffer carry processions of mortuary and other deities advancing towards figures of Nesisut who offers to them an image of Maat, the goddess of truth; at the foot end of the coffer there is a rather crude outline of the boat of the sun-god containing the deity in his morning form of Khepri, the beetle, within the solar disc; above, on the foot of the lid is a rather better figure of the goddess Isis, kneeling with outstretched protective wings, in her attitude of one of the traditional divine mourners for the dead.

The very end of the northern side gallery is occupied by a wall-case with four charming divine animal sculptures in different materials, all fine examples of the close observation the Egyptian artist applied to the animal world. A bronze seated figure of a lioness-headed goddess represents Uadjit, a Delta deity (no. 24785); it is hollow and was a receptacle for a mummified creature sacred to Uadjit, possibly an ichneumon. A limestone seated jackal, slightly gauche, but wholly appealing, presents the distinguished necropolis god Anubis with little of his usual dignity (*fig.* 62). The painted wooden figure of a baboon represents the god Thoth, the scribe of the gods, in almost a domestic manner; his face is gilded and his eyes are inlaid (no. 20869). The fourth figure is the most unusual of the group (no. 51100). The falcon-god Horus is depicted as a Roman emperor, seated on a throne. The falcon head is placed very neatly on the human body, and the transition from bird to human is cleverly effected through the feathering on the

62 Anubis, the jackal-god, deity of mummification and guardian of the necropolis. This limestone statuette lacks the proud dignity of conventional depictions. Height 51 cm. (no. 47991)

head and neck changing gradually into the scales of the armoured singlet which protects the upper part of the body. This figure is made of limestone and may be dated to the first century AD.

From the time of the renaissance in Egyptian art which began under the Nubian kings of the Twenty-fifth Dynasty, sculpture was the predominant field in which the Egyptian artists displayed their skills; and in the making of statues they exercised greatest originality in the modelling of the face. Many heads remain conventional in the treatment of the features; others are carved with an emphasis of certain features which seem at first sight to be portraits, or attempts at portraiture, but in fact are 'realistic', frequently brutally so, yet still conventional according to a newly developed tradition; others again are so individual in their detail that they are generally thought to be true attempts at portraiture, and such essays become more common and more successful as the centuries down to the Roman Period advance.

A number of heads at the north end of the side gallery illustrate the various styles and developments. On the right-hand wall is an exceptionally finely finished head of a young man in schist (*fig. 63*); it comes from Alexandria, may be dated to the first century BC, and it displays a mixture of Egyptian and Greek characteristics; the contrast between the smoothly finished face and the unpolished curls of the hair has been pointed out as a feature of heads carved in this manner. On the opposite side of the gallery are two more heads, of very different styles. The crystalline limestone piece on the left, which may be dated to the Twenty-fifth Dynasty, is a good example of the 'false' portrait of the period (*fig. 2*); in the form of the wig and in the way in which the face is delineated, it is an archaising sculpture in the manner of the Middle Kingdom (no. 37883); the heavy eye-lids, large ears and high cheek-bones are distinctly reminiscent of representations of King Sesostris III, four sculptures of whom have been seen in the southern part of the main gallery (nos. 608, 684–6). The head on the right is of granite and has some claim to be regarded as a portrait, or near portrait (no. 55252). The hair is represented in a manner found on a number of sculptures of the late Ptolemaic Period, and early Roman period, to the later of which it probably belongs; the features, on the other hand, are far from being conventional or stylised; the face is deeply furrowed, and a serious attempt has been made to reproduce the individual bone structure of the skull. The standing statue between these two heads if of interest because it is unfinished (no. 1229); the rectangular block held in front of the figure would have been carved into a shrine containing an effigy of a god. It has instead been given a rough inscription in modern times to enhance the interest of the piece; but the person who chose so to inscribe it selected a text of a much earlier period; the statue is of the fifth century BC, the text of a kind used about twelve hundred years earlier.

Returning to the main gallery, for the purposes of this survey by way of the ramp, the visitor is faced by two imposing red granite

63 Alexandrian schist head of a young man, exhibiting Greek as well as Egyptian sculptural traits. Note the very high degree of finish in the carving of the face. Height 24.5 cm. (no. 55253)

coffin lids separated by a colossal face from another coffin in black granite. The two complete lids are both of the Nineteenth Dynasty, but very different in style. The one on the right is the more conventional (no. 18); it was made for Pahemnetjer, High Priest of Ptah at Memphis, and the head is carved in traditional manner. The head of Setau, Viceroy of Kush, and the owner of the coffin on the left (no. 78), is almost grotesque, moon-like and set at an angle. In

other respects this second lid is carved in an highly competent manner, and it is difficult to account for the strange head. Other known representations of this very important person do not suggest that he had exceptional facial features. The head in between the two lids (no. 140) is part of the great sarcophagus placed in the tomb of King Ramesses VI of the Twentieth Dynasty (c. 1156 – 1148 BC). For many years after it reached the British Museum it was incorrectly identified as Amenophis III. As a royal representation of a late Twentieth-dynasty king it is of great rarity, and very different in style from the carvings of Amenophis III, a number of which can be seen for comparative purposes in the Central Saloon.

The adjacent bay holds two divine statues which come from Karnak, both larger than life-size, one in grey quartzite and the other in black granite. The first shows the god of the Nile inundation, Hapy (*fig. 64*), a somewhat epicene figure with heavy breasts and sagging stomach, the divine embodiment of richness and natural fertility. The figure seems to stand in a marshy place, and it holds an offering table piled to overflowing with the produce of the land. The dedication of the statue was made by the High Priest of Amun, Sheshonq, the son of Osorkon I of the Twenty-Second Dynasty (c. 924 – 889 BC), and there can be little doubt that the standard portrait of this king served as the model for the features of this Hapy. It is clearly an earlier example in the tradition which produced the sunk relief representation of King Osorkon II, grandson of Osorkon I, which was noted earlier in the gallery (no. 1077). A bold relief of the dedicator, Sheshonq, is carved on the left side of the statue; he is shown wearing a priestly leopard-skin cloak. The second statue is a further example of the seated representations of the lioness-deity Sakhmet which were made in the reign of Amenophis III of the Eighteenth Dynasty. The present statue, however, left uninscribed in the reign when it was made, bears the name of King Sheshonq I, the predecessor of Osorkon I (no. 517).

Beyond the great grey granite sarcophagus of Hapmen (no. 23) which was found by the

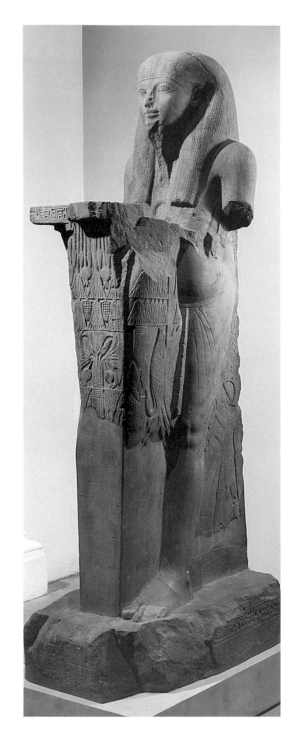

French Expedition used as a bath in the mosque of Ibn Tulun in Cairo, and formerly known as the Lover's Fountain, are a number of sculptures of the Twenty-sixth Dynasty. The phenomenal skills practised by sculptors of this period in the carving of hard stones is finely exemplified by the great coffin-lid of Sisebek (*fig. 65*), a piece which well deserves to be included in a survey of sculpture on account of the excellence of the head and of the unusual sensuousness of the representation of the body which in most anthropoid coffins is rendered with great simplicity. Sisebek was the northern vizir of Egypt during the reign of Psammetichus I (664 – 610 BC), and he undoubtedly had the best sculptors at his command. Apart from the fine, but conventional, face, notice should be taken of the crisply carved kneeling figure of the sky-goddess Nut, with outstretched protective wings, above the two lines of offering texts which run down the body.

Two kneeling figures of high officials of the same period are placed to the north of Sisebek's coffin-lid. The first is exceptional, above other considerations, because of its size, approaching two metres in height, and being, therefore, larger than life-size – a rare colossal figure of a non-royal person. It is a basalt figure of Wahibre, who was, among other things, a military commander in the Delta during the later part of the Twenty-sixth Dynasty, just before the disastrous invasion of Egypt by the Persians in 525 BC (no. 111). Wahibre is shown holding a small shrine, or naos, on his knees which contains an effigy of the god Osiris. Perhaps because of its unusual size this sculpture is distinguished by a simplicity in its modelling and by a restrained use of detail. The face is very full, and displays a form of idealized portraiture which developed during the later Twenty-sixth Dynasty, and continued in use for several centuries. As a sculptural representation of an individual it is far less interesting, perhaps less successful, therefore, than its neighbour, the quartzite statue of Nekhtherheb (*fig. 66*). The subject here, who occupied his high office during the reign of King Psammetichus II (595 – 589 BC), holds no shrine on his knees, and is presented

64 Quartzite statue of the god of the Nile-flood, Hapy, shown with the features of the contemporary king Osorkon I. The relief figure of Osorkon's son, Sheshonq, the dedicator of the statue, can be seen on the side. Height 2.20 m. (no. 8)

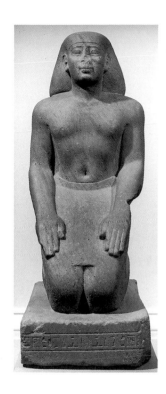

65 *right.* Coffin-lid in basalt of Sisebek, Memphite vizier in the early Twenty-sixth Dynasty. The crisp carving of the head, and the subtle suggestion of bodily forms within the summary treatment of the whole are remarkable. Height 2.23 m. (no. 17)

66 *above.* Kneeling quartzite figure of Nekhtherheb. The head of the statue is slightly raised in an attitude of reverential worship, sometimes described as apotheosis. Height 1.14 m. (no. 1646)

in the simple, submissive, act of kneeling before the deity, in this case Osiris, from whom he seeks benefits. The temple from which this votive statue came is not known; it was one of the first pieces of Egyptian sculpture to reach Great Britain in the early eighteenth century, but it did not enter the British Museum until 1914. Nekhtherheb is shown wearing the same wide wig of Wahibre's statue; the head is less full and rather more individual than that of the colossal statue, and the body is modelled with greater attention to musculature and the definition of detail.

The exit from the Sculpture Gallery at its northern end is marked by a kind of short 'processional way' of the type so commonly found in Egyptian architecture, often made up of varying and disparate elements. There is no real homogeneity in what is offered here, and the dates of the individual pieces range from the reign of Ramesses II (*c.* 1304 – 1237 BC) to the second century AD.

The way is dominated by two granite columns with palm-leaf capitals. The column on the left comes from the great temple of Bastet at Bubastis in the Delta (no. 1065); the one on the right from the temple of the ram-headed god Arsaphes at Heracleopolis in Middle Egypt (no. 1123). Both were initially inscribed in the reign of Ramesses II, but later the names of Osorkon II of the Twenty-second Dynasty were added to the former, and those of Ramesses' successor, Merneptah, to the latter. The 'processional way' continues with a pair of small basalt obelisks (nos. 523, 524) erected by, and inscribed with the names of, King Nectanebo II of the Thirtieth Dynasty (360 – 343 BC). Obelisks were erected before the great formal doorways of temples, and from the inscriptions on these two it is clear that they were designed for a temple of Thoth, but the precise temple has not yet been identified with certainty. The inscriptions on these two monuments are very finely carved with well designed hieroglyphs furnished with excellent internal detail. A final pair of monuments flank the northern door of the gallery – two limestone female winged sphinxes of Greek inspiration, and quite unlike the traditional

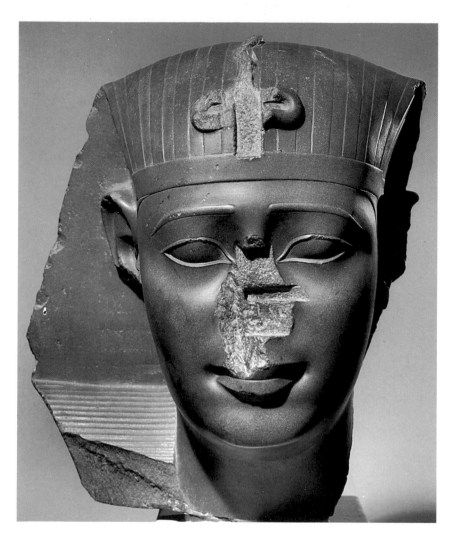

67 Green schist head of a king, possibly Amasis or Nectanebo I. Well documented portraits of the kings of the Twenty-sixth and later Dynasties are rare. Height 38 cm. (no. 97)

scarab-beetle was the creature associated with the god Khepri, the form of the sun-god Re at the time of his birth in the morning. There is a fine colossal scarab of the reign of Amenophis III beside the Sacred Lake in the Temple of Karnak, but it is not as large as the British Museum example. Size, however, is the principal feature of this piece; it is carved in accordance with its rather gross conception. It is of uncertain date, and unknown original provenance. In modern times it was found in Constantinople to which it had probably been transported in Imperial Roman times. To the right of the scarab stands one of the finest royal heads in the whole collection. It is carved from schist of a peculiarly fine green colour with a superlative mastery of technique and a sensitive modelling of the features (*fig. 67*). The appearance is badly marred by the loss of the nose and part of the lips; a mortice slot, cut undoubtedly to receive a repair, may be ancient, perhaps of Roman date. This damage initially prevents a proper appreciation of the head's quality, but close attention quickly reveals its special distinction. Although the treatment of the face contains elements which suggest an early Ptolemaic date, particularly the mouth, other features, like the eyes and the relatively high cheek-bones, taken in conjunction with the superior finish, point to an earlier date; both Amasis of the Twenty-sixth Dynasty and Nectanebo I of the Thirtieth Dynasty have been suggested as the subject. A second slot on the brow was cut for the replacement of the damaged head of the uraeus-serpent.

A relief representation of Nectanebo I can be seen on one face of a large basalt slab mounted at the end of the northern raised area of the gallery, to the right of the green schist royal head. This slab, of the kind known as intercolumnar, was originally placed between two columns in a Delta temple (no. 22); the scene shows Nectanebo kneeling and making an offering of a loaf to the deity of the temple. In the group of inscriptions mounted on the east wall of the gallery to the left of the green schist head, is one from a temple at Kom Abu Billo in the western Delta (no. 649). It is a limestone fragment of a scene showing the King Ptolemy I

Egyptian sphinx which was usually male and without wings (nos. 1604, 1605). It has been stated that these figures came from a temple of Ptolemy IX in Upper Egypt, but they more probably were placed at the entrance to a tomb of a much later date, possibly of the second century AD.

Before the Sculpture Gallery is left, a few more pieces of interest need to be noted, not least of which is the great granite scarab placed centrally in the 'processional way' (*fig. 68*). The

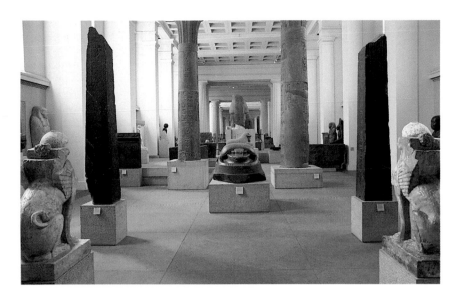

68 View of the northern end of the Egyptian Sculpture Gallery looking south along the short 'processional way' marked by the granite temple columns, the obelisks and the pair of female sphinxes. In the centre is the great scarab. Height of scarab 89 cm. (no. 74)

(305 – 282 BC) making an offering of flowers to a form of Hathor; it already displays some of the full, rounded, contours of the characteristic Ptolemaic relief sculpture, but the influence of the fine tradition of the last Pharaonic dynasties is still in evidence. The carving of detail is remarkably crisp. On the end wall of the gallery to the right of the door is a huge black basalt sarcophagus lid bearing a high relief figure of the deceased owner, lacking the head (no. 90). The body is represented wearing a kind of long garment introduced into Egypt during the Persian Period (525 – 404 BC). It has been suggested that this lid belongs to a royal sarcophagus, and that the head would have been shown wearing one of the royal crowns. No parallel can be at present found, and both the status of the owner and his date are uncertain. Nevertheless there is no doubt about the boldness of the carving of the figure, which is almost three-quarters in the round. There is a certain strict formalism in the conception, which is suitable for a mortuary carving which would have been so closely associated with the body of the subject itself.

In the corresponding space to the left of the door stands an imposing granite shrine which was found in the ruins of a Coptic church on the Island of Philae, and was presented to the British Museum by the Egyptian Government in 1886 (no. 1134). It was carved during the reign of Ptolemy VIII, Euergetes II (170 – 116 BC), and it bears the names of the king and of his wife, Cleopatra II. The texts include a dedication to the goddess Isis, the principal deity of Philae, and originally it contained a figure of the goddess herself, or of some other associated deity. On its left, flanking the doorway leading into the Nineveh Gallery of the Department of Western Asiatic Antiquities, are two more interesting heads from statues of the Late Period, both approximately life-sized.

On the left is a royal head in grey granite (no. 633), the identification of the subject of which raises serious problems. No crown appears to be shown, and the head of the uraeus-serpent lies directly on the royal brow, with its body forming a double coil, the tail snaking up to the crown of the head. There is a brutal quality about the features of the face which suggests a Twenty-fifth-dynasty date, but no convincing parallel can be found among royal portraits of that time, which can be identified with some certainty. The head on the right is also unidentified (no. 1316), but a better attempt can be made at dating it than its royal fellow. Although it is divorced from its body, this head can be shown to be set in such a way that the face is looking slightly upwards. This attitude is one of divine glorification, the subject gazing up in worship of the deity from whom he seeks benefits; it is sometimes described as apotheosis, perhaps rather loosely. It is an attitude of moderate ecstasy met occasionally in Egyptian sculpture of most periods, but especially in the Twenty-fifth and Twenty-sixth Dynasties, and again during the Ptolemaic Period. This head belongs to the last period, and is a good example of its type; the bulbous eyes are characteristic, but the modelling of the facial features is sufficiently unconventional to suggest that it may be a portrait.

Here the survey of the Egyptian Sculpture Gallery ends. But there are further exhibitions in the upper galleries of the Museum in which Egyptian sculpture plays an important part.

The Upper Galleries

Passing through the door at the north end of the Sculpture Gallery, the visitor reaches the staircase which leads up to the Egyptian galleries on the first floor. Notice may be taken of a great fist of a granite colossus of Ramesses II from Memphis (no. 9), and a sandstone lion-gargoyle, a water spout, from the temple at Coptos (no. 69027), in the vestibule at the bottom of the stairs; and of four standing granite figures of the lioness-goddess Sakhmet from Thebes, on the second landing (nos. 41, 53, 519, 520). Material of sculptural interest can be found in all six of the Egyptian upper galleries and in the Coptic Corridor, but the displays of special significance are in the galleries traditionally called the Fourth, Fifth and Sixth Egyptian Rooms (numbered 63, 65, and 64 on the Museum plan).

The Fourth Egyptian Room is devoted to illustrating aspects of Egyptian daily life. Artists and their techniques are dealt with in wall-cases 180–183; among the objects on display is a standing figure of a king of the Roman Period (no. 1209) which is in an unfinished state. It is carved from basalt and seems to be complete apart from its final polish. Closer examination reveals that the right eye is very imperfectly carved, while the nose is broken off. It may, therefore, have been abandoned as a spoiled piece; still it shows admirably the rough state of a hard stone sculpture in its last stage of making before polishing. The wooden figure of a woman, possibly the wife of Meryrehashtef, whose fine statuette was seen in the southern side gallery, is also unfinished; a guide-line in black paint bisects the body (no. 55723). Sculptures in other materials illustrate other skills and techniques. The damaged upper part of what must have been a magnificent bronze figure of a man (no. 22784) reveals through its damage much of the sand core which was used in the modelling of the piece. It was ultimately cast using the lost-wax process, the most common technique used for bronze figures. A most unusual exception is a massive figure of a ram-headed deity (no. 60093) which was a solid casting in bronze, but made in three pieces presumably because of the difficulty of casting such a large piece in one pouring of metal. A further sculpture to be noted in this technical display is a terracotta bust of large size (no. 21920). Again it seems to be a piece which was too big to be moulded and baked in one firing; the wig in particular was probably added after the initial firing.

In the adjacent wall-case 178, among objects concerned with scribes, is a particularly fine scribal statue in purplish quartzite (*fig. 11*). It represents Pes-shu-per, the chamberlain of the God's Wife of Amun, Amenardis, and as a sculpture of the mid-Twenty-fifth Dynasty it shows archaising characteristics: the scribal form itself harks back to Old-kingdom originals, although the treatment of the legs here is less than summary; the form of the double wig is based on Eighteenth-Dynasty models. As a whole, however, the sculpture has distinct individuality in the treatment of the head; it is a fine representative of the artistic renaissance of its time. In the extension of the scribal exhibition in floor-case J one of the most important documents for the understanding of Egyptian sculpture and two-dimensional art can be seen. It is a wooden drawing-board of the kind used by students and others whose work required them to make sketches or notes (*fig. 14*). Such boards are covered with a thin layer of gesso-plaster, and what was written or drawn could be wiped away, perhaps a number of times. There is clear indication that erasures have been made on this board. What can be seen, however, is of the greatest interest. The left half of the surface on display is marked out in red with a grid, within which is drawn with exquisite line a seated figure of a king, identified by cartouches as Tuthmosis III of the Eighteenth Dynasty (*c.* 1504 – 1450 BC). Here is a drawing of a male figure (who happens to be a king) made punctiliously according to the canon of proportions within the controlling grid (see page 16). For the standing figure, eighteen squares were specified at this period from the ground level to the line of the wig above the eye. The seated figure here takes fourteen squares; the balance of four can be measured along the thigh. The drawings of arms and a chick on the

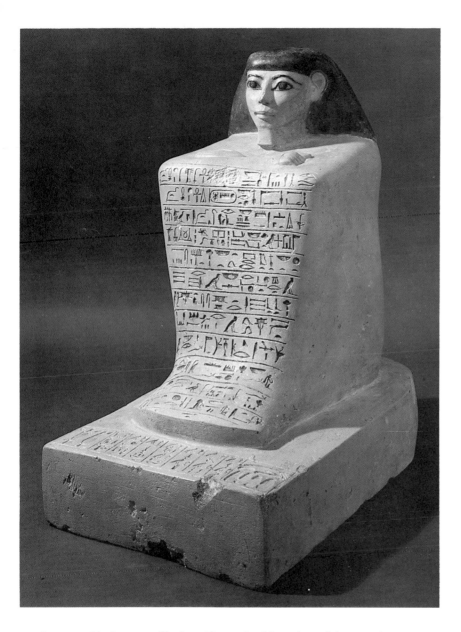

69 Limestone block statue of Inebny. The stark white colour of the stone is dramatised by the partial use of paint: black on the wig and to enhance the eyes, and blue in the signs of the inscription. Height 51.5 cm. (no. 1131)

right seem to be practice attempts at two standard hieroglyphic signs.

Other displays in the Fourth Egyptian Room contain interesting sculptures, used to illustrate particular themes of daily life. In the wall-cases 161–163 devoted to weapons and warfare sits a limestone block-statue of Inebny (*fig. 69*), a commander of an infantry unit during the reigns of Queen Hatshepsut and King Tuthmosis III. It is a votive sculpture in this classic form, very simple in conception and unelaborate in execution. The head is conventionally carved, but rendered very striking by the use of black paint for the wig and for outlining the eyes. The invocatory text on the front of the piece shows in its first line the deliberate destruction of the name Hatshepsut, who had dominated royal rule in Egypt during the early years of the reign of Tuthmosis III. In wall-case 167 nearby are exhibited some of the tools used by stone-workers in ancient Egypt. Here they illustrate particularly the working of stone vessels, but some of them could have been used for the production of stone sculpture.

Sculpture in various materials forms the bulk of the exhibition in the Fifth Egyptian Room. In general stone sculpture occupies the north side (the left side on entering the room from the Fourth Room), and bronze figures the south side, but there are many exceptions to this arrangement. Figures in wood are also shown, and a few in ivory and terracotta. This room, however, will undergo modification from time to time, so precise references to particular pieces in fixed positions will be kept to a minimum.

The stone sculpture is arranged chronologically in the wall-cases on the north side, and some small pieces are included in the floor-cases on the same side. A very appealing statue-group of Old-kingdom date is shown in wall-case 193. It depicts the high official Katep and his wife Hetepheres (*fig. 70*), seated side by side, and of equal height, which is unusual for man and wife in Egyptian art. Following colour conventions Hetepheres is painted yellow, and Katep brownish-red, indications of indoor and outdoor activity. Seated thus, with the wife's

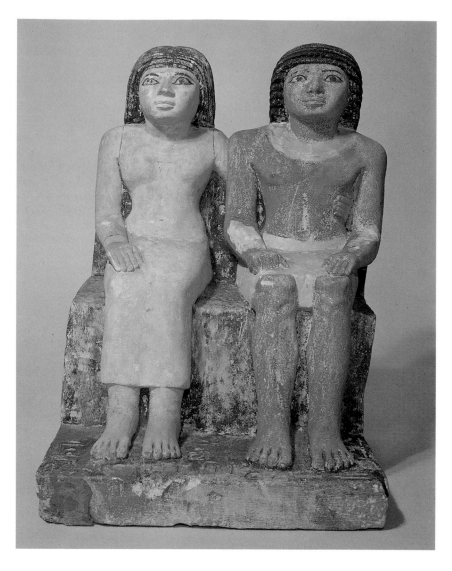

70 *above*. Painted limestone pair-statue of Katep and Hetepheres, an attractive example of a common type of tomb sculpture showing a man and his wife affectionately seated side by side. Height 47.5 cm. (no. 1181)

71 *right above*. Black granite head carved in the tradition of royal portraiture of the mid-Eighteenth Dynasty. It may represent not a royal personage but a goddess; perhaps part of a group statue. Height 25.5 cm. (no. 956)

72 *right below*. Head in granite of a man, probably a high official, of the Twenty-fifth Dynasty, shown wearing a wig characteristic of the Fifth Dynasty about one thousand six hundred years earlier in date. Height 17.5 cm. (no. 67969)

arm around the husband's waist, the pair radiate conjugal contentment, suitable vessels for their spirits when they return from the after-life, and very satisfactory images for eternity.

Among the many pieces of sculpture to be seen in the remaining wall-cases, some may be singled out for special mention. In wall-case 194 the granite figure of Ameny is a fine example of Twelfth-dynasty funerary sculpture (no. 777); the body is very competently modelled, and the head is set slightly on one side and is turned up in the attitude of adoration of the deity, sometimes described as apotheosis. A very appealing small sculpture in wall-case 197, unfortunately uninscribed, shows a priest kneeling and holding an offering table in front of himself (no. 21979); he is shown wearing a leopard skin and the heavy side-lock, both of which indicate the priestly office known as 'pillar of his mother'. The head is most attract-ively carved, and its appearance is strikingly heightened by the large eyes outlined in black. Among pieces of the reign of Akhenaten displayed in wall-case 199 are two faces made of plaster, one representing possibly a princess, one of the daughters of Akhenaten and Nefertiti (no. 65517), the other, much more realistic, probably a senior member of the royal court (no. 65656). The plaster material of the former is finer and lighter in colour than that of the latter, but these differences may not have special significance in the determination of why and how they were made. Studies of other, similar, masks from Amarna have postulated that some at least were death masks, but this conclusion has been challenged on grounds of technique, inherent probability and on comparison with the very few apparently certain death masks that have been found elsewhere. It is now thought that the Amarna masks were made as sculptor's studies for the making of stone por-traits, and that they were made by taking casts from originals modelled in clay or wax. The realism found in these plaster portraits was perhaps due to the rapid manner in which the original likeness was modelled in some plastic material; when used as the basis for a sculpture in stone most of the individuality of the originals

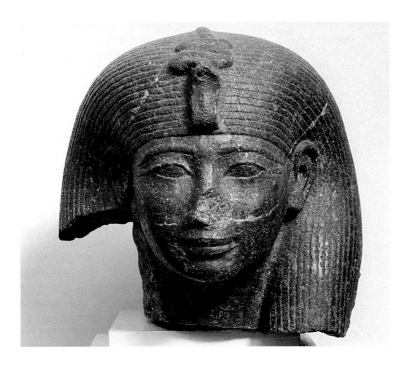

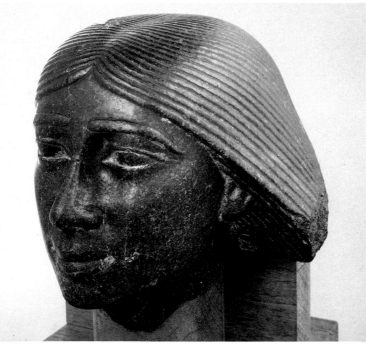

would be eliminated in the slow process of carving.

Wall-cases 203–206 contain many interesting small sculptures of the Late Period. Attention may be drawn in 203 to two very different sculptures representing Harwa, the major-domo of Amenardis, of the Twenty-fifth Dynasty. The smaller, which is the more unusual (no. 32555), shows him squatting and holding two effigies of goddesses in front of himself; here he displays the raised gaze of the adorant. The second is more conventional, a block statue in schist, bearing votive texts (no. 55306). It is unlikely that either presents a true portrait of Harwa. In the next case stands a fine schist statuette of the priest Un-nefer (no. 55254), who is shown holding a figure of the god Khons-pa-khered – a splendid example of a conventional type of votive sculpture placed in temples, like that of Karnak, from which this piece comes. Very similar in conception, but much more individual in execution, especially as far as the head is concerned, is the statuette of Nefer-sema-tawy in wall-case 206 (no. 65443). The deity being held here is Horus, the effigy standing in a small shrine.

A black granite head placed on a pedestal between wall-cases 197 and 199 presents the student of Egyptian sculpture with a problem of identification (fig. 71). It represents a royal or divine personage wearing a tripartite wig, with the uraeus-serpent on the brow; it should come from a statue of a goddess, but there are other possibilities. The discovery of the remainder of the statue – an event which has happened for other divorced heads in the British Museum – might solve the problem, provided that it is inscribed with an identificatory text. On another pedestal, but under glass, is another anonymous head of great interest (fig. 72). It is again of black granite, but is of a man wearing a wide wig of a kind characteristic of certain sculptures of the Fifth Dynasty. It was found in excavations in the Temple of Mut in Karnak, and is undoubtedly dated to the Twenty-fifth Dynasty. As far as the wig is concerned it is another archaising piece of the renaissance of the Nubian and Saite Dynasties.

The wall-cases in the opposite half of the

Fifth Egyptian Room, on the south side, are devoted to an exhibition of divine figures, with a few of uncertain divinity among them. The majority are made of bronze, and they provide a very good representative selection of the Museum's large holdings of such figures. It is an exhibition of great diversity and from it much can be learned of the iconography of particular Egyptian deities, and of the technical mastery possessed by Egyptian craftsmen in casting and working bronze. Two very fine standing figures of women, probably priestesses, are shown in wall-case 215 (nos. 43371 and 43372). They are in style, but not in detail, similar to the bronze female figure (no. 43373) already noticed in the side gallery off the northern part of the Sculpture Gallery. These two have likewise lost their gilded gesso-plaster, and have suffered some surface corrosion; yet they still exhibit considerable grace, and provide convincing testimony of the ability of bronze-workers of the Late New Kingdom to cast figures at a much larger scale than was normal in ancient Egypt. In wall-case 213 two stone heads of divine animals prove once again how sympathetically and successfully Egyptian artists interpreted the animal world. The alabaster head of a cow (*fig. 73*) comes from Deir el-Bahri where Hatshepsut's mortuary temple included provision for the cult of Hathor, here regularly shown as a cow. The granite jackal head (no. 64400), very sensitively observed, and finely carved, is a fragment which has greatly increased in interest since its parent body was found in Thebes. The whole monument showed the jackal of Anubis, the funerary deity, seated, characteristically, on a shrine; an inscription dates it to the time of Amenardis, God's Wife of Amun during the middle reigns of the Twenty-fifth Dynasty.

The Sixth Egyptian Room, which is reached to the south of the Fourth Egyptian Room, contains pieces of great importance in the early history of Egyptian sculpture, and a great many small-scale sculptures in glazed composition or faience. Of very special interest are the two figurines in floor-case A. They both belong to the Badarian Culture, one of the earliest stages in the predynastic period to which distinctive cultural characteristics can be assigned. These two figurines, one in ivory (*fig. 74*), and one in terracotta (no. 59679), are among the very earliest sculptures from Egypt which can be dated (in the early fourth millennium BC) with a reasonable degree of certainty. In terms of dynastic sculpture the first is very crude, and displays no characteristics which are recognisably Egyptian. It is, nevertheless, very well executed and has considerable conceptual power. Artistically it is far less advanced than the second figurine in terracotta; this piece is very sensuously modelled with careful, but not excessive, attention being given to the female bodily features. It is quite exceptional among predynastic figurines for the excellence of its modelling and the perfection of its finish. Sadly, it has lost its head. It is difficult to believe that both these pieces belong to the same culture, but the circumstances of their excavation are beyond question.

Two objects made probably in the century before the foundation of Egypt as a unified kingdom at the beginning of the First Dynasty are the slate palettes with relief scenes known as the Hunters' Palette and the Battlefield Palette. These pieces are thought to be large ceremonial examples of the small slate palettes used for the grinding of eye-paint. The Hunters' Palette (no. 20790 and 20792) in floor-case B carries a relief scene of a wild animal hunt, perhaps of ritual character; it may even contain symbolic reference to the internal struggles which led to the unification of Egypt. Hunters wearing feathers on their heads, and with tails hanging from their waist-bands, attack animals which occupy the greater part of the field – lions, an ostrich, deer, gazelle, wolf, bubalis and rabbit. The figures of the hunters are ranged around the edge of the palette, while the animals are scattered in what appears to be disorganized confusion. The scenes on the Battlefield Palette (*fig. 75*) are far better organized with, on the obverse side, something approaching the arrangement in registers commonly found in Egyptian art throughout the Pharaonic Period. The piece is shown in floor-case C so that it can be seen on both sides.

73 *above*. Alabaster head of a cult-statue of the goddess Hathor in cow-form. It was originally embellished with a feathered headdress and horns, all probably gilded; the eyes were inlaid with rock-crystal and lapis lazuli. Height 35.5 cm. (no. 42179)

74 *right*. Ivory figurine of a woman of the Badarian culture—the earliest of the cultures considered to be precursors of the dynastic culture of Pharaonic Egypt. Height 14 cm. (no. 59648)

75 The Battlefield Palette. The scene shows a lion, probably representing the king, seizing his enemies. The upper part is a cast of a fragment in the Ashmolean Museum, Oxford. Height with cast 31.3 cm. (no. 20791)

In the battle on the obverse side the principal figure is that of a lion mauling a man; it has commonly been interpreted as a scene of the Egyptian king, shown as a lion, destroying his enemies. Dead bodies are shown in the lower part of the scene receiving the attention of birds of prey. Here it is sufficient to draw attention to the excellence of the carving, and the presence of certain classic dynastic features in the representation of the human body. In both palettes heads are shown in profile, but eyes frontally, but on the Hunters' Palette the eyes are represented simply as drilled holes. Bodies are shown with the shoulders presented frontally and legs in profile. The reverse of the Battlefield Palette carries a scene of two long-necked animals of unidentified species standing on either side of a palm-tree.

Faience objects, including many small sculptures in the material, are exhibited in floor and wall-cases in the eastern half of the Sixth Room. Miniature animal figures in faience are among the best observed and most attractive objects from ancient Egypt. In wall-case 26 may be seen an unusual hippopotamus figure (fig. 76). Such figures are not uncommon from the Middle Kingdom, and they show the animal standing four-square and painted with marsh plants, as if it were standing in its natural habitat. The example under discussion is more freely modelled; it shows the hippopotamus raised up on its fore-legs and turning its head in a great roar; faint traces of the marsh plants can be seen on the very worn glaze of the body.

The purposes for which these small faience figures were made are not fully understood; inasmuch as some clearly represent animals sacred to particular deities, religious or amuletic intentions may be perceived. But purposes apart, these little sculptures demonstrate in small scale the same appreciation of form, and the same skill in craftsmanship, which have been observed in the colossal statues of the temple complexes, and in the moderately sized pieces from tomb and temple, which distinguish the Egyptian collections of the British Museum.

76 Faience figure of a hippopotamus turning and roaring, probably the male animal often shown hunted in the marshes of Egypt. Marsh plants can faintly be seen painted on the body. Height 15.5 cm. (no. 36346)

Bibliography

C. ALDRED
The Development of Egyptian Art from 3200 to 1315 BC
London, 1962

C. ALDRED
Egyptian Art
London, 1980

CAROL ANDREWS
The Rosetta Stone
London, 1981

B.V. BOTHMER
Egyptian Sculpture of the Late Period
New York, 1960

W.V. DAVIES
A Royal Statue Reattributed
London, 1981

H.G. EVERS
Staat aus dem Stein, 2 vols.
Munich, 1929

W.C. HAYES
The Scepter of Egypt, 2 vols.
New York, 1953, 1959

T.G.H. JAMES
The British Museum and Ancient Egypt
London, 1981

T.G.H. JAMES
An Introduction to Ancient Egypt
London, 1979

K. LANGE and M. HIRMER
Egypt: Architecture, Sculpture, Painting in Three
Thousand Years
London and New York, 1968

H. SCHÄFER
Principles of Egyptian Art
Oxford, 1974

W.S. SMITH
The Art and Architecture of Ancient Egypt,
new ed., revised by W.K. Simpson
Harmondsworth, 1982

W.S. SMITH
A History of Egyptian Sculpture and Painting in the
Old Kingdom
London, 1946

J. VANDIER
Manuel d'archéologie égyptienne, III. La statuaire,
2 parts
Paris, 1958

Index to the collection numbers of the objects mentioned in the guide

Note: Numbers with asterisks refer to illustrations

Dynasties of Egypt with selected Kings

All dates given are approximate

Early Dynastic Period
(DYNASTIES I – II)

First Dynasty
c. 3100 – 2890 BC

Second Dynasty
c. 2890 – 2686 BC

Old Kingdom
(DYNASTIES III – VIII)

Third Dynasty
c. 2686 – 2613 BC

Djoser
c. 2667 – 2648 BC

Fourth Dynasty
c. 2613 – 2494 BC

Cheops (Khufu)
c. 2589 – 2566 BC

Mycerinus (Menkaure)
c. 2505 – 2477 BC

Fifth Dynasty
c. 2494 – 2345 BC

Sahure
c. 2487 – 2473 BC

Nyuserre
c. 2456 – 2425 BC

Unas
c. 2375 – 2345 BC

Sixth Dynasty
c. 2345 – 2181 BC

Meryre Pepi I
c. 2312 – 2263 BC

Neferkare Pepi II
c. 2249 – 2175 BC

Seventh Dynasty
c. 2181 – 2173 BC

Eighth Dynasty
c. 2173 – 2160 BC

First Intermediate Period
(DYNASTIES IX – X)

Ninth Dynasty
c. 2160 – 2130 BC

Tenth Dynasty
c. 2130 – 2040 BC

Middle Kingdom
(DYNASTIES XI – XII)

Eleventh Dynasty
c. 2133 – 1991 BC

Wahankh Inyotef II
c. 2117 – 2069 BC

Nebhepetre Mentuhotpe II
c. 2060 – 2010 BC

Twelfth Dynasty
c. 1991 – 1786 BC

Sehetepibre Ammenemes I
c. 1991 – 1962 BC

Kheperkare Sesostris I
c. 1971 – 1928 BC

Nubkaure Ammenemes II
c. 1929 – 1895 BC

Khakheperre Sesostris II
c. 1897 – 1878 BC

Khakaure Sesostris III
c. 1878 – 1843 BC

Nymare Ammenemes III
c. 1842 – 1797 BC

Makherure Ammenemes IV
c. 1798 – 1790 BC

Second Intermediate Period
(DYNASTIES XIII – XVII)

Thirteenth Dynasty
c. 1786 – 1633 BC

Sekhemre Sewadjtowy
Sobkhotpe III
c. 1744 – 1741 BC

Khasekhemre Neferhotep I
c. 1741 – 1730 BC

Fourteenth Dynasty
c. 1786 – 1603 BC

Fifteenth Dynasty
(Hyksos)
c. 1674 – 1567 BC

Sixteenth Dynasty
c. 1684 – 1567 BC

Seventeenth Dynasty
c. 1650 – 1567 BC

Nubkheperre Inyotef VII
c. 1650 – 1645 BC

Sobkemsaf I
c. 1642 – 1626 BC

New Kingdom
(DYNASTIES XVIII – XX)

Eighteenth Dynasty
c. 1567 – 1320 BC

Nebpehtyre Amosis I
c. 1570 – 1546 BC

Djeserkare Amenophis I
c. 1546 – 1526 BC

Akheperkare Tuthmosis I
c. 1525 – 1512 BC

Akheperenre Tuthmosis II
c. 1512 – 1504 BC

Makare Hatshepsut
c. 1503 – 1482 BC

Menkheperre Tuthmosis III
c. 1504 – 1450 BC

Akheprure Amenophis II
c. 1450 – 1425 BC

Menkheprure Tuthmosis IV
c. 1425 – 1417 BC

Nebmare Amenophis III
c. 1417 – 1379 BC

Neferkheprure Amenophis IV
(Akhenaten)
c. 1379 – 1362 BC

Ankhkheprure Smenkhkare
c. 1364 – 1361 BC

Nebkheprure Tutankhamun
c. 1361 – 1352 BC

Kheperkheprure Ay
c. 1352 – 1348 BC

Djeserkheprure Horemheb
c. 1348 – 1320 BC

Nineteenth Dynasty
c. 1320 – 1200 BC

Menpehtyre Ramesses I
c. 1320 – 1318 BC

Menmare Sethos I
c. 1318 – 1304 BC

Usermare Ramesses II
c. 1304 – 1237 BC

Baenre Merneptah
c. 1236 – 1223 BC

Userkheprure Sethos II
c. 1216 – 1210 BC

Twentieth Dynasty
c. 1200 – 1085 BC

Usermare-Meryamun
Ramesses III
c. 1198 – 1166 BC

Hiqmare Ramesses IV
c. 1166 – 1160 BC

Nebmare Ramesses VI
c. 1156 – 1148 BC

Late Dynastic Period
(DYNASTIES XXI – XXX)

Twenty-first Dynasty
c. 1085 – 945 BC

Twenty-second Dynasty
c. 945 – 715 BC

Hedjkheperre Sheshonq I
c. 945 – 924 BC

Osorkon I
c. 924 – 889 BC

Usermare Osorkon II
c. 874 – 850 BC

Pimay
c. 773 – 767 BC

Twenty-third Dynasty
c. 818 – 715 BC

Twenty-fourth Dynasty
c. 727 – 715 BC

Twenty-fifth Dynasty
c. 747 – 656 BC

Piankhi (Piye)
c. 747 – 716 BC

Neferkare Shabaka
c. 716 – 702 BC

Khunefertemre Taharqa
c. 690 – 664 BC

Twenty-sixth Dynasty
c. 664 – 525 BC

Wahibre Psammetichus I
c. 664 – 610 BC

Wehemibre Necho II
c. 610 – 595 BC

Neferibre Psammetichus II
c. 595 – 589 BC

Haibre Wahibre (Apries)
c. 589 – 570 BC

Khnemibre Amosis II (Amasis)
c. 570 – 526 BC

Ankhkaenre Psammetichus III
c. 526 – 525 BC

Twenty-seventh Dynasty
c. 525 – 404 BC

Twenty-eighth Dynasty
c. 404 – 399 BC

Twenty-ninth Dynasty
c. 399 – 380 BC

Thirtieth Dynasty
c. 380 – 343 BC

Kheperkare Nectanebo I
c. 380 – 362 BC

Snedjemibre Nectanebo II
c. 360 – 343 BC

Macedonian Kings
c. 332 – 305 BC

Alexander the Great
c. 332 – 323 BC

Philip Arrhidaeus
c. 323 – 317 BC

Ptolemaic Kings
c. 305 – 30 BC

Ptolemy I Soter I
c. 305 – 282 BC

Ptolemy V Epiphanes
c. 205 – 180 BC

Ptolemy VIII Euergetes II
c. 170 – 116 BC

Cleopatra VII Philopator
c. 51 – 30 BC

Index

Photo Acknowledgments

The photographs on pages 24, 26, 37 and 67 are reproduced by kind permission of David Finn; and on page 8 by kind permission of Dr I.E.S. Edwards; those on pages 11 and 13 are the copyright of T.G.H. James. All other photographs have been provided by the Photographic Service of the British Museum and the work of Peter Hayman is particularly acknowledged